Paris in New York

French Jewish Artists in Private Collections

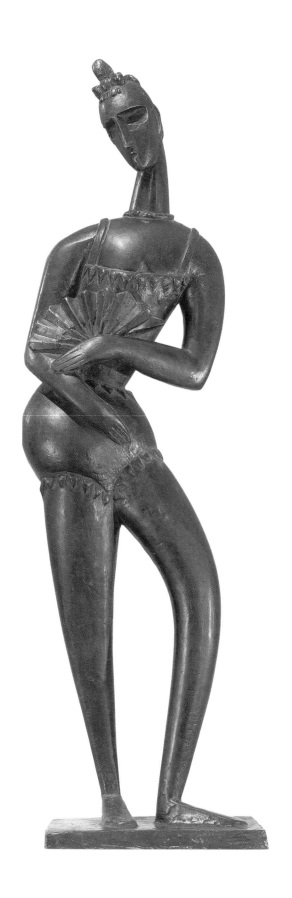

Fig. 1
Jacques Lipchitz
Horsewoman with Fan, 1913
Bronze, 26¾ x 7¼ x 7¾ in.
(67.9 x 18.4 x 19.7 cm)
Courtesy of Marlborough Gallery,
New York

Paris in New York

French Jewish Artists in Private Collections

Edited by Susan Chevlowe

Essay by Romy Golan

The Jewish Museum ❖ New York
Under the auspices of The Jewish Theological Seminary of America

This book has been published in conjunction with the exhibition *Paris in New York: French Jewish Artists in Private Collections*, presented at The Jewish Museum, New York, March 5–June 25, 2000.

Paris in New York: French Jewish Artists in Private Collections was made possible by the generous support of its donors:

A special appropriation obtained by Governor George E. Pataki and the New York State Legislature
The Florence Gould Foundation
The Morris S. and Florence H. Bender Foundation
Credit Lyonnais
Louis and Anne Abrons Foundation
Fanya Gottesfeld Heller

Exhibition Curator: Susan Chevlowe
Exhibition Assistant: Sarah Timmins DeGregory
Exhibition Designer: Daniel Bradley Kershaw
Exhibition Graphic Designer: Sue Koch
Catalogue Editor: Janice Meyerson
Catalogue Designer: Nancy Foote

ISBN # 0-87334-079-5
Library of Congress Card Catalogue Number 00-131238

COVER IMAGE: Amedeo Modigliani, *Portrait of Beatrice Hastings,* ca. 1916. Detail. (Plate 29).

Contents

Foreword

IN THE FIRST DECADES of this century, an era that marked the transformation of French painting, many Jewish artists in France were part of a group of painters and sculptors known today as the School of Paris. The work and lives of these artists were first given substantial attention in a 1985 Jewish Museum exhibition, *The Circle of Montparnasse: Jewish Artists in Paris, 1905-1945,* which was curated by scholars Kenneth E. Silver and Romy Golan working with The Jewish Museum's curator, Susan Goodman. Over the past 15 years, the subject has provided a rich area for curatorial work, one that continues with this exhibition, *Paris in New York: French Jewish Artists in Private Collections.*

School of Paris works are highly valued and sought after today, and the collectors of the works of Jewish artists share not only an appreciation of the beauty of these works, but also an abiding curiosity about the lives of the artists. The histories of the paintings in this exhibition reveal that works once traded among friends have crossed the globe and are now in private hands here in New York, and many of the works have had surprisingly few owners in the intervening years since their creation. The recent boom in art collecting has brought onto the market works that might otherwise have remained in the hands of the heirs of some of the original friends and family of the Circle of Montparnasse and this phenomenon has resulted in a dispersion of the works among distinguished private collections.

Paris was among several cultural capitals of the Western world prior to World War II where Jews worked as professional artists. The Jewish Museum has mounted a series of notable and popular exhibitions that have explored the works of these artists. Some have evolved out of *The Circle of Montparnasse,* such as monographic exhibitions over the last decade of the works of Chaim Soutine, Marc Chagall, and Jacques Lipchitz. Others have examined groups of artists and their relationship to one another, such as *The Immigrant Generations: Jewish Artists in Great Britain* (1983), *Painting A Place in America: Jewish Artists in New York, 1900-1945* (1991); *Russian Jewish Artists in a Century of Change, 1890-1990* (1995), and *Berlin Metropolis: Jews and the New Culture, 1890-1918* (1999).

Paris in New York includes thirty-eight works by a dozen artists, all of whom found inspiration in the vibrant and beautiful City of Light. These predominantly East-European born Jewish artists settled in Paris beginning in the first decade of the twentieth century. They include Marc Chagall, Sonia Delaunay, Moïse Kisling, Jacques Lipchitz, Mané-Katz, Louis Marcoussis, Amedeo Modigliani, Elie Nadelman, Chana Orloff, Jules Pascin, Chaim Soutine, and Max Weber. With the majority of the paintings and sculpture borrowed from private collections in the New York area – and supplemented with major examples from The Jewish Museum collection – *Paris in New York* brings into public view extraordinary and celebrated works rarely seen before.

This exhibition covers the most vibrant and innovative years of the School of Paris, from 1907 to

1939. Paris was a mecca for Jewish artists from diverse geographic, economic, and religious backgrounds until the disruption of the encroaching threat of Nazi Germany at the end of the 1930s. Originally attracted to the cosmopolitan culture of the city that was a haven for bohemians and foreigners alike, most of this community was dispersed by the onset of World War II. Nurtured by the cosmopolitan environment of the city and the company of like-minded artists these painters and sculptors made significant contributions to the stylistic development of French modernist painting.

From the Museum's past experience with mounting exhibitions of this nature, we expect *Paris in New York* to be widely appealing to people of all cultural backgrounds. While Jewish culture is the context of the Museum, and Jewish culture informs the interpretation of the exhibition, this is ultimately an exhibition of magnificent works by artists who, as we take a retrospective look at the century, have shaped our view of Western visual culture.

This project has been a collaboration between Museum staff and the private collectors who have graciously given us entrée into their homes and generously parted with their works for the duration of the exhibition. Susan Chevlowe, Associate Curator, was the principle organizer of this exhibition, and she worked efficiently and thoughtfully to bring into public view a beautiful assembly of work that expresses the dynamic creativity of Jewish artists who were part of the School of Paris. I thank her for her excellent work and also thank Sarah Timmins DeGregory, who has contributed enormously to every aspect of exhibition planning and the production of this handsome catalogue. Ruth K. Beesch, Deputy Director for Program, and Norman L. Kleeblatt, Susan and Elihu Rose Curator of Fine Arts,

helped to locate important works and shape the interpretive context for the show, and many other staff members played important roles in developing, funding, and publicizing the exhibition, handling the loans, and mounting the exhibition in the galleries. I appreciate their commitment and dedication to this project.

The lenders, listed on page 64, are, of course, at the very heart of the exhibition's content. We are grateful to them for sharing their love of art and their interest in this fascinating period of art history. They have allowed the Museum to create an exquisite presentation. Also essential to the project have been the tremendously supportive donors. Many thanks go to Governor George E. Pataki and the New York State Legislature, through whom the Museum received a special appropriation for this exhibition, and The Florence Gould Foundation and Credit Lyonnais, which have consistently supported exhibitions of French art at The Jewish Museum. Deep appreciation is also extended to The Morris S. and Florence H. Bender Foundation, the Louis and Anne Abrons Foundation, and Jewish Museum Trustee Fanya Gottesfeld Heller, all long-time supporters. Finally, it is important to mention that the entire exhibition program at the Museum is enthusiastically endorsed and supported by The Jewish Museum's Board of Trustees, headed by the current chairman, Robert J. Hurst. This exhibition deepens our understanding of the Jewish School of Paris artists known as The Circle of Montparnasse, who produced a body of work that provides infinite pleasure and fascination.

Joan Rosenbaum
Helen Goldsmith Menschel Director
The Jewish Museum, New York

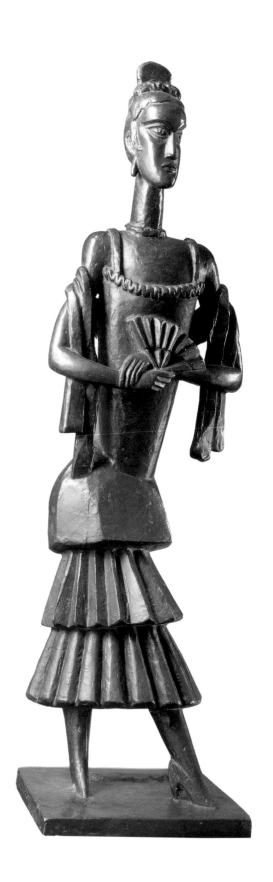

Fig. 2
Jacques Lipchitz
Spanish Dancer, 1914
Bronze, 29 in. (73.7 cm) high
Private collection

Acknowledgments

THE JEWISH MUSEUM has benefited enormously from the assistance and cooperation of dozens of people who have contributed to the making of this exhibition. The public will benefit as well. I am extremely grateful to the supporters and friends of the Museum – both new and old – who so graciously gave of their time during the months of planning *Paris in New York: French Jewish Artists in Private Collections*. I have had the privilege of meeting and speaking with many wonderful, and generous people; most important are the lenders themselves, listed on page 64.

In addition, I would like to acknowledge the tremendous assistance of Sarah Timmins DeGregory in coordinating all aspects of this project, and the other members of the Fine Arts Department who have worked on this exhibition and catalogue, Marie Rupert, Irene Zwerling Schenck, Katharina Garrelt, and former staff member Michelle Lapine. In addition, I am grateful for the support and expertise offered by Norman L. Kleeblatt, Susan and Elihu Rose Curator of Fine Arts, Susan T. Goodman, Senior-Curator-at-Large, Ruth K. Beesch, Deputy Director for Program, and Joan Rosenbaum, Helen Goldsmith Menschel Director.

The professional contributions of so many people outside the Museum have been indispensible to bringing this project to fruition. I would like to thank Ida Balboul, Amy Baumann, Emily Braun, Felicia Cukier, Nancy Foote, Romy Golan, Dina Goldberger, Gloria Henry, Oliver Hirsch, Heather Johnson, Daniel Bradley Kershaw, Sue Koch, Jeff Kopi, Maureen McCormick, Janice Meyerson, Meredith W. Nix, John Parnell, Marc Porter, Suzanne L. Shenton, Judith Chused Siegel, and Charles von Nostitz. For their words of advice, for their time, and for their cooperation, I thank Jacob Baal-Teshuva, Carol Boltin, Himan Brown, Phillip A. Bruno, Elaine Lustig Cohen, Martha and Jonathan Cohen, Benjamin Fischoff, Ida Glezer, Cissy Grossman, Arnold Katzen, Julie Martin and Billy Klüver, Diane Maas and Susan Merrick, Bella Meyer, Achim Moeller, Hanno Mott, Cynthia and Jan Nadelman, Joel Rosenkranz, Jane Schoelkopf, Alexandra Schwartz, Laura Skoler, Dalia Tawil, and Joy S. Weber.

Susan Chevlowe
Associate Curator
The Jewish Museum, New York

9

The Last Seduction

Romy Golan

THE STORY of the group of Jewish artists who came to live and work in Paris in the first decades of the twentieth century is now well known. The term "Circle of Montparnasse," coined by Kenneth E. Silver, is now used even by the French themselves, no small achievement for American art history.[1]

Many of the artists in the present exhibition managed to rescue themselves from wretched poverty and assured obscurity in the provincial cities and shtetls of Eastern Europe. In Paris, they gravitated first to a residence for destitute artists called La Ruche, near the Vaugirard slaughterhouses in the 15th arrondissement. Soon they found their way to another artists' housing colony called Cité Falguière, nearer to the center of the city, and finally they came to the new neighborhood of Montparnasse, in the 14th arrondissement. Just a few years after their arrival, many of these artists already had one-person shows to their names in Paris's major art galleries and had achieved a substantial measure of financial success. Indeed, the speed at which their success was achieved was unprecedented.

Not all the artists from the Circle of Montparnasse came from unpropitious backgrounds. While the artists from Eastern Europe were escaping the pogroms of Russia and Poland and came to Paris without much hope of returning to their homelands, some, such as the American Max Weber and the Italian Amedeo Modigliani, came to Paris by choice, as had previous generations of young foreigners. Paris in the early twentieth century supported a network of art schools catering to young foreigners. Weber came from New York in 1905 as an art student and made the rounds of the independent art academies, enrolling first at the Académie Julian, then at the Académie Colarossi, and finally at the Académie de la Grande Chaumière, before helping to establish the Matisse Academy in 1908. Not desiring to become an American expatriate in Europe, Weber eventually returned to New York.

Modigliani came from a well-to-do family of tradesmen from the old Sephardic community of Livorno and had already attended art schools in Florence and Venice when he set out for Paris in 1906. Whereas Weber had come to Paris from the new world to study great art *in situ*, Modigliani came to Paris seeking bohemia. Upon his arrival, he lived in Montmartre, where he circulated among the artists who lived or congregated at the complex of artists' studios known as the Bateau Lavoir. The pivotal figure of this group was the young Pablo Picasso, who maintained a studio there until 1912.

The story of Modigliani, with his weakness for alcohol, his early death from tuberculosis, and the suicide of his lover, Jeanne Hébuterne (the day after his death), has a *fin-de-siècle,* decadent tinge. The stories of the flights of Marc Chagall, Chaim Soutine, Jules Pascin, Moïse Kisling, Jacques Lipchitz, and Chana Orloff from Eastern Europe to Paris had, to the contrary, an exhilarating quality. Like the myriad nineteenth-century French novels about provincials trying their luck in the big city, their life stories were told again and again, not only in articles and exhibition catalogues, but in the new format of the popular novella in series of pocket-size monographs published in the 1920s by Gallimard, the Éditions Crès, and in a series dedicated to Jewish artists published by Le Triangle.

Art critics constructed a kind of *tableau vivant* in which each artist played an almost scripted role. Modigliani was the tall, refined, and frail aristocratic artist. Pascin, who came to Paris from Bulgaria via

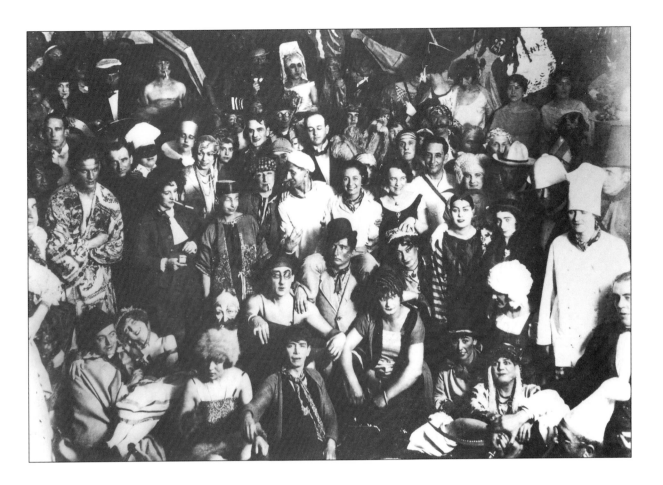

Munich and was a fixture at every costume ball in town, was described alternately as the ultimate "Montarno" (denizen of Montparnasse) or as a pasha reigning over his harem. Chagall, with his halo of curly hair and his belted peasant blouses, figured as the beloved storyteller from the Russian town of Vitebsk. He was the modern-day bard whose lyrical paintings came to evoke for French viewers both an exotic world of Jewish tales and consoling memories of a French favorite in literature, tales of pre-Revolutionary Russia. Soutine was the destitute artist from the shtetl of Smilovitchi in Byelorussia whom fate, as much as talent, had transformed almost overnight (he was "discovered" in 1922 by the American collector Alfred Barnes) into a successful artist. Although he sometimes dressed like a dandy (we see him in photographs wearing double-breasted

Fig. 3
Jules Pascin may be pictured at lower left, with a woman in his arms, at the Maison Watteau, one of the frequent costume balls held in Paris in the mid-1920s on Rue Jules Chaplain.

suits and impeccably polished shoes), Soutine's relentlessly anguished paintings were evidence that one could not always escape one's adverse past.

The fact that these artists came *en masse* to Paris around 1910, found themselves living together in close quarters at La Ruche, creating an almost instant new art community, was thrilling to the Parisian art scene. Even if Paris was still considered by most the mecca of modern art, by the 1910s the city was living off a reputation for creativity and nonconformism that it had earned decades earlier. Montmartre, whose bohemian atmosphere had attracted young Picasso in 1901, had become passé. Montparnasse, where the majority of the artists in this show spent most of their time, was, by contrast, a truly modern place. With sections of the Boulevard Raspail, between the Boulevard du Montparnasse and the Rue Vavin, still being constructed in 1902, Montparnasse was the most modern quarter downtown.[2] It was the perfect antidote and the perfect substitute for the slightly soporific atmosphere of Montmartre. With its heterogeneous population, its large café-terraces sprawling along its sidewalks, its noisy smoke-filled restaurants and brasseries, its dance halls and nightclubs – Le Dôme, Le Select, La Coupole, Le Café du Parnasse – arrayed in close ranks along its main drag, the Boulevard du Montparnasse, and clustered on the four corners of the Carrefour Vavin, Montparnasse was the only neighborhood in Paris that could compete with the other modern, cosmopolitan city in Europe: Berlin.

But in contrast to gritty Berlin and Moscow – the other avant-garde city on the rise in Europe in the teens and twenties – Paris remained a capital of hedonism. From the *Belle Epoque* to the *Années Folles* (the Roaring Twenties), Paris managed to remain the "moveable feast" so memorably described by Ernest Hemingway.[3] The shift of the artistic community from Montmartre to Montparnasse signaled the merging of the avant-garde with the *beau monde*. During the carefree years of the aftermath of World War I, the Paris art scene was marked by a surge of upward mobility, wherein artists who had previously led a bohemian existence on the fringe of the demimonde now hobnobbed with the well-to-do. A previously stultified aristocracy was suddenly eager to be found in the company of artists, and Picasso, Kees Van Dongen, Pascin, Kisling, Robert and Sonia Delaunay, and even the Surrealists found themselves seduced by this possibility. Everyone profited from these contacts. Yet what distinguished the Jewish artists of Montparnasse is that they ultimately remained, to a remarkable extent, outsiders. Even after they managed to achieve financial security in the late twenties and early thirties, Soutine, Chagall, and Pascin still moved in a bohemian world, with all its splendors and miseries. They continued to be classified as *peintres maudits* (accursed painters), and a neo-Romantic *frisson* always remained associated with their names.

It is ironic that these Jewish artists – children of an iconophobic tradition – should have proved the most vigorous and effective defenders of oil painting. The Second Commandment forbids pictorial representation of the human figure: "Thou shalt not make graven images of anything that is in heaven above, or in the earth beneath, or that is in the water beneath the earth." The paradox of this new phenomenon – Jewish painting – was the point of departure of a series of controversial articles published in 1925 in the venerable review *Mercure de France*. Fritz Vanderpyl, the author of the first of these articles, noted that he had not seen a single work in the Louvre by the hand of a Jewish artist. He asked, "Where did it come from, and so suddenly, this desire to paint on the part of these descendants of the twelve tribes, this passion for paintbrush and palette, which – in spite of the Law – is being tolerated, even encouraged, in the most orthodox circles?" Failing to detect what could be termed a Jewish "style" in the works of Soutine, Kisling, and others, Vanderpyl resorted to worn but always effective anti-Semitic cliché: the Jewish penchant for mercantil-

ism. Now that art had become thoroughly commodified, a conspiratorial cabal of Jewish dealers, collectors, and critics encouraged other Jews to produce the proper wares: oil paintings and sculptures.[4] Their work did not stem from a legitimate will to art, but from monetary motives.

Trying to deflate this argument, the critic and art dealer Adolphe Basler pointed out that this new and unprecedented phenomenon of Jewish artists was part of the recent history of Jewish assimilation. The Jews, having come out of ghettos, were now able to reflect the artistic culture of the country in which they lived, as opposed to continuing to express only their own ethnic heritage. Choosing to be an artist, he claimed, was for a Jew the same as embracing any other liberal profession, such as that of doctor or lawyer.[5] Taking a middle road, the art historian Elie Faure distinguished between the worlds of art and commerce in an essay on Soutine in 1929. After asking, "Where does it come from, this genius of his for painting, so rare in the Middle East, and almost unknown among Jews?" Faure attributed the extraordinary energy and urgency of Soutine's painting to the barriers being broken between Jews and the world of culture after centuries of their exclusion from that world. After having been confined to commerce and banking, Jews were moved by a will to make art.[6] Florent Fels was still exclaiming almost thirty years later, "Isn't it amazing that the spell of Paris has attracted so many Jewish artists to commit that ultimate sin – to give priority to the human figure?"[7]

In the face of painterly abstraction – which styled itself explicitly as an iconoclasm – the Jewish painters of Montparnasse remained faithful to representation. Moreover, this was a time when, even beyond abstraction, the very legitimacy of easel painting and its place within modernism was being questioned. Iconoclasm took a number of forms in Paris during those years: Dada spread from Zurich to Cologne, Berlin, New York, and Paris during World War I; Marcel Duchamp and Piet Mondrian,

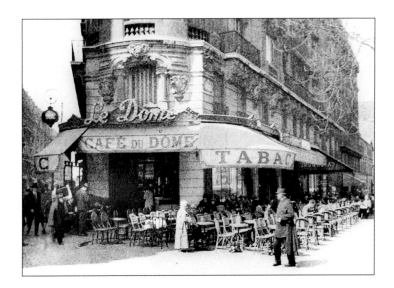

Fig. 4
Le Dôme, ca. 1910. The café opened on
the Boulevard Montparnasse in 1898.

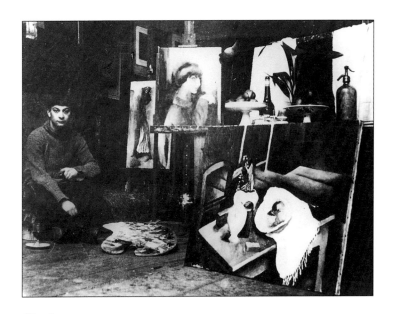

Fig. 5
The artist Moïse Kisling photographed ca. 1916
amid his paintings at his studio on Rue Joseph-Bara.

the "fathers" of the ready-made and the grid, respectively – the two most radical challenges to painting (and to sculpture) in the first half of the twentieth century – lived in Paris almost throughout the interwar years. Another challenge to pictorial tradition came in the form of pastiche, that self-conscious and sometimes parodic imitation of an earlier style. Picasso, in his turn to neoclassicism during World War I and the years that followed, repeatedly flirted with the idea of pastiche. There was also Surrealist "psychic automatism," with its unfettered release of pigment on canvas.

The Jewish painters of Montparnasse could not afford to be modernist iconoclasts. They had only recently earned the right to be painters. In their earnest devotion to painting and sculpture, Jewish artists remained almost impervious to the powerful iconoclastic forces that were changing the rules of art. Modigliani, for example, was one of the first painters in Paris to engage, at the outset of the war, in a neoclassical treatment of the figure in portraits and the nude. André Derain and Picasso, when they chose to paint the figure in a neoclassical mode in those years, were consciously and strategically recoiling from the chaos of Cubism or of war itself. But Modigliani was neither reacting against nor returning to anything by embracing the figure. He saw himself as the legitimate heir to his Italian forebears, making reference to the linear purity and serenity of the masters of the Quattrocento.

Pascin's painterly nudes allowed critics to indulge in erotic fantasies about Paris as a "city of women," illicit male fantasies absent from modernist painting since the nineteenth century. A fixture in the wildest parties of Montparnasse, Pascin was a man whose life was deemed as sybaritic as his paintings. His fleshy nudes, slumped on plush armchairs and sofas, offer the nacreous surface of their skin to the viewer. Yet this was not quite the escapism offered by Orientalism. The sad and disenchanted expressions of Pascin's models, the squalidness of their surroundings, and the pallid and often lurid light illu-

minating the scene seem unmistakably modern. Not by chance did Basler title one of his books on Montparnasse *Le Cafard après la fete* (literally, "The Funk After the Feast," but also understood as "Down in the Dumps After the Orgy"). Also capturing the disenchanted atmosphere of Pascin's paintings during those years are the photographs by the Hungarian Brassai, another immigrant Jew from Eastern Europe working in Paris. Brassai's extraordinary photographs of prostitutes parading before prospective customers in the elaborate *mise-en-scène* of old brothels now function as documents as much as fantasies of the underbelly of Paris. Pascin's images remain, for all their disenchantment, forever escapist.

Chagall was more than an enchanting storyteller. His nostalgic tales of the Russia of his childhood – peopled by violinists dressed in purple and green playing on village roofs, colorful peasants seated around tables next to samovars, floating lovers holding tender bouquets – fulfilled more than the work of any other artist of his time the ardent yet suppressed desire of so many viewers for what had become another taboo of modernism: narrative painting.

In sculpture, as in painting, the artists of the Circle of Montparnasse avoided iconoclasm. While Picasso's tinkering with different found materials in his Cubist sculpture opened the door to Duchamp's ready-mades and the Surrealist object, the sculptures of Lipchitz and Orloff belonged to what one may call Deco-Cubism. Their figures of circus acrobats, violinists, guitarists, and accordion players stood opposite the depersonalized robotic figures of the New Man of the machine age, one of the main legacies of Cubism. These performers were charming modern-day troubadours. Orloff, largely because of her portraits, was perhaps the most successful woman sculptor working in Paris in the 1920s and '30s. Her elegant, highly stylized bronze and wood portraits of art collectors, fellow artists, and *femmes du monde* are perhaps the closest we may get to grasping the glamour of Paris during those years. Like that of

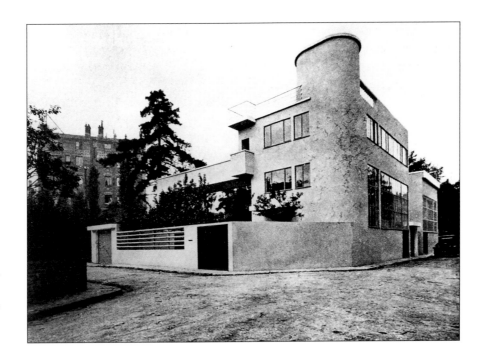

Fig. 6
The twin studio houses designed by the architect Le Corbusier for the sculptors Jacques Lipchitz and Oscar Miestchaninoff, Boulogne-sur-Seine, France, 1924.

Sonia Delaunay, possibly the subject of *Woman with an Overcoat (Sonia)* (in a private collection), Orloff's work refers to the world of *couture*. In the portrait, Sonia wears a long wrapping coat with a shawl collar reminiscent of her own designs and of Paul Poiret's "Orientale" line. Many of Orloff's sculpted portraits, showing women dressed in the latest fashion, belong to the revival of a premodernist genre in the 1920s: the *portrait mondain*. As it became fashionable again for sitters to strike aristocratic, languid poses, one finds an entire gallery of such portraits of *Parisiennes* and elegant expatriates.

But it is Soutine who stood at the crux of the question of the survival of easel painting. This point was made in 1998 by Kenneth E. Silver and Norman L. Kleeblatt in their exhibition *Soutine: An Expressionist in Paris* at The Jewish Museum, New York. As popular as he was, Soutine remained by far the most controversial of the artists of the Circle of Montparnasse. Basler used the German term *Schmiermalerei* (smeared painting) to describe Soutine's pictorial surface. The mixed connotation

of the word "smeared" and the foreignness of the word at a time – between the two World Wars – when not much love was spared between France and Germany encapsulated the French ambivalence toward Soutine's work. The many essays written on Soutine all alternated between attraction and repulsion, the spiritual and the abject, the sublime and the pathological. Faure's and Waldemar George's monographs of 1928 and 1929, the two most memorable books written about the artist, raise the issue of how much one can extemporize on thick impasto and oily canvases, manic execution, ugly and deformed human bodies, eviscerated animals, and painfully uprooted landscapes without collapsing into anti-Semitic stereotypes.[8]

A larger issue raised by these texts is, why were the French, by the late 1920s, so taken by Expressionism as a pictorial style? And why were they so intent on taking over the legacy of Expressionism? It was, I would propose, because by 1928 the concept of Expressionism – another term the French knew they were appropriating from the Germans –

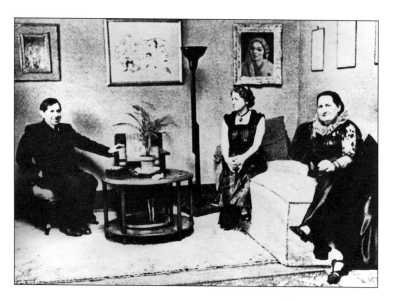

Fig. 7
Chana Orloff, far right, in her house designed by the architect Auguste Perret in the Villa Seurat, a street in Montparnasse. Chaim Soutine and another friend, Olga Sacharoff, are also pictured.

stood for much more than yet another modernist "-ism." It came to stand for "Painting." The problem was that the French had already formulated their own version of agitated, brightly colored painterliness, in a style called Fauvism. Their use of the term "Expressionism" had to be explained so as not to make it sound like a dismissal (and a demise) of Fauvism in favor of a German type of painting. So French critics continued to ask into the 1940s and '50s, *"Existe-t-il un expressionisme français?"*[9] These critics proposed endless – and often spurious – dichotomies between Northern and Southern, Western and Eastern, Latin and Slavic, ordered and chaotic ways of painting highly textured and highly colored canvases. While Fauvism was about *joie de vivre*, they claimed, the painful contortions of German Expressionism were the harbinger of times of trouble; while Fauvism was controlled and ultimately still the child of French Cartesianism, Expressionism could easily run amok; while Fauvism was native, Expressionism was "other." This was an exercise that was not merely the product of a nationalist, or even a racist, worldview, but something intrinsic to the discipline of art history. For indeed, the best way to make an argument about style, from the foundational writings of Heinrich Wölfflin onward, has been to define it in every way possible as one style in opposition to another style.[10]

Exhibitions are the best way to turn convoluted art-historical arguments into practice. So in 1928, a Paris exhibition entitled *L'Expressionisme français* featured Maurice Vlaminck, Georges Rouault, and Maurice Utrillo as French artists; and Chagall, Modigliani, Moïse Kisling, and Soutine as foreigners living in Paris. In his review, the painter and critic André Lhote was quick to notice the absence of Germans from the show: "It seems quite paradoxical that one could organize in France today an exhibition under the aegis of a word that has ceased to be used on the other side of the Rhine. We know in fact that in Germany, the official motherland of Expressionism, this pictorial mode is no longer in

favor....Modern-day Expressionism is born in France and it is in our country that it will certainly reach its true blossoming."[11]

In Germany by the mid-1920s, the pictorial Expressionism of Die Brücke had largely been supplanted by the *Neue Sachlichkeit* (New Objectivity) in the works of Otto Dix, Max Beckmann, and Christian Schad. While the violence of mood, the bodily distortions, and even the loud acidic colors of earlier Expressionism survived in their work, the thick, gestural, and tactile impasto – the very mark of painting – did not. Evenly smooth to the point of slickness, affectless in the handling of pigment, and almost hallucinatory in its pristine outlining of forms, especially in the case of Dix and Schad, the painting of the *Neue Sachlichkeit* was haunted by the existence of photography. Photography (for example, the work of Albert Renger-Patszch and August Sander) – not painting – was at the heart of

Fig. 8
The heart of Montparnasse: the intersection of the Boulevard Montparnasse and the Boulevard Raspail.

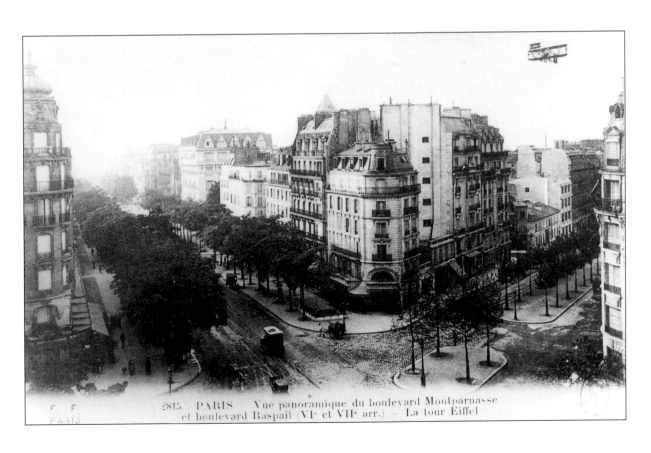

F F PARIS 2815 PARIS Vue panoramique du boulevard Montparnasse et boulevard Raspail (VIᵉ et VIIᵉ arr.) – La tour Eiffel

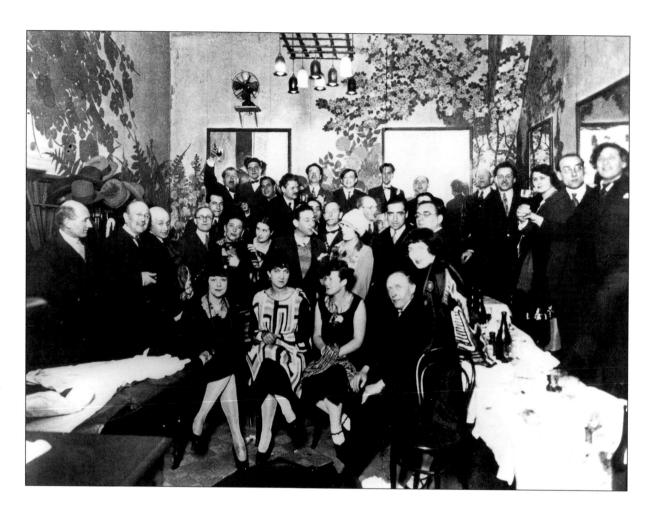

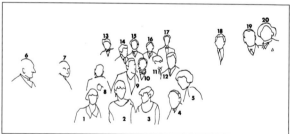

Fig. 9
A luncheon at the Closerie des Lilas on the Boulevard de Montparnasse honoring the painter Georges Rouault included many members of the Jewish artistic community of Montparnasse. A photograph of the event shows Juliette Roche Gleizes, who was married to the French painter Albert Gleizes (1); Madame Florent Fels, who was married to the art critic and is wearing a dress designed by Sonia Delaunay (2); Madame Marcel Gromaire, who was married to the painter (3); Rouault (4); Bella Chagall, who was married to the painter (5); the artists Jean Crotti (6), Louis Marcoussis (7), Alice Halicka (8), Léopold Lévy (9), and Per Krohg (10); possibly the architect Le Corbusier (11); the critic Waldemar George (12); and the artists and writers Georges Duthuit (13), Simon Lévy (14), André Favory (15), Jacques Lipchitz (16), André Salmon (17), André Lhote (18), Florent Fels (19), and Marc Chagall (20).

Sachlichkeit. To the relief of the French – who were much more intent and more successful than the Germans, Russians, or Americans in keeping photography at bay, at the margins of modernism – the specter of photography never came to haunt the paintings of Soutine, Chagall, Kisling, or Pascin.

In Paris, the year of the French Expressionism show, even the Surrealist André Breton, although he disapproved of the kind of painterliness favored by Lhote, retreated from his previous position and made a new plea for easel painting, in *Surrealism and Painting*, which should be read as a recanting of the iconoclastic "excesses" of automatism – the term with which Breton had defined Surrealism in his 1925 *Manifesto*. The loss of authorial control over pictorial production in the unconscious discharge provoked by automatism, as well as the unorthodox use of materials other than paint, had gone too far for Breton's taste, and he reinstated the representational function of oil painting. An oft-quoted passage reads: "It is impossible for me to envisage a picture as being other than a window, and my first concern is to know what it *looks out* onto.... Within the frame of an *undefined full-length portrait, landscape, or seascape* I can enjoy a tremendous spectacle."[12]

A 1930 response to Breton's *Surrealism and Painting* was *La Peinture au défi* (Challenge to Painting), by another major Surrealist poet, Louis Aragon. Retracing step by step Breton's art-historical narrative, making reference to the same artists, Aragon retold the history of early twentieth-century art, but from a standpoint outside the media of oil painting and sculpture. His account, which amounted to a radical rewriting, placed Dada's iconoclasm at its center. It began with Picasso and Georges Braque's Cubist *papiers collés*, Max Ernst's Dada *collages*, Duchamp's ready-mades, Hans Arp's wood reliefs, Francis Picabia's stencil machine drawings and paintings made from matches, André Masson's spilled sand paintings, and Joan Miró's asphalt painting, and ended with Salvador Dalí's use of bits of chromo-photographs amid what initially looked like straight oil painting. With startling aplomb, Aragon declared: "Painting has not always existed; we can determine when it began. And if its development and its moments of greatness have been repeatedly drummed into our heads, can we not then also imagine its periods of decline and even its end, as for any other concept? Absolutely nothing would be changed in the world if no one painted any more, though such a view of things will not pass without alarming the conservative spirit of art lovers. Let them be reassured: we haven't the optimism to assert that the day will come when no one will paint any more, but what we can project is that painting will certainly, in the not too distant future, pass for the harmless diversion reserved for young girls and old provincials, as is true today for poetry in verse, and will be true tomorrow for the writing of novels."[13]

At the time Aragon wrote these words, he had just returned from the Second Congress of Revolutionary Writers in Moscow, where he had been invited by the Soviets to deliver a paper. In contrast to Alfred Barr, The Museum of Modern Art's curator-at-large, who returned to New York from his trip to the USSR in 1927 almost empty-handed and baffled at not having been able to find any contemporary painting to buy, Aragon was intent to capitalize on what he saw: he had witnessed firsthand, after years of advocating the revolutionary efficacy of Surrealism to recalcitrant members of the French Communist Party, a revolutionary culture that had rejected easel painting as an obsolete, passé, bourgeois activity and had moved on to what it called "Productivism." Photography, photomontage, sculpture made of scraps of industrial materials, poster design, textile design, equipment design – the Soviets now made sure to produce everything *but* painting.

Aragon's position obviously found few advocates in Paris. Berlin seemed at times not so far from Moscow in the years after the Revolution, but Paris seemed light-years away. A painter such as Chagall

served as the paradigmatic example of what had supposedly gone wrong with the Soviet Union: here was a man who had initially come to Paris fleeing the Russian pogroms, but his works were steeped in a nostalgia for old Russia; he returned to Russia during World War I, joined the Revolution, and was named Commissar of Fine Arts in his hometown of Vitebsk in 1918, but fell out of favor with the regime by 1922; after stopping in Berlin, he was back in Paris by 1923. Here was a man, then, who had chosen France not once, but twice, as a safe haven and a second motherland. Back in Paris, Chagall resumed painting images of fiddlers on roofs and flying lovers holding exquisite bouquets, as if nothing had happened either in his life or in Russia since he had left Paris in 1914. Indeed, while in the teens his delightful depictions of the Russian village had repressed the misery of everyday life in the shtetl and the trauma of the pogroms, his paintings of the 1920s and, to an overwhelming extent, the 1930s, repressed the Revolution.[14]

In 1933, eight months after Hitler's takeover, Expressionism was finally included by a French art critic as a subcategory of Fauvism. In "Les Peintres juifs: Modigliani et l'inquiétude nostalgique," in the magazine *L'Amour de l'art*, the critic Roger Brielle included the Jewish artists of Montparnasse under a new category, "Le Fauvisme pathétique." This was an expedient way of finally assimilating these foreign painters into the French fold, as well as an ecumenical gesture. For, as Brielle wrote, everywhere one turned, one saw a frightful rise of xenophobia and anti-Semitism; it was thus imperative to remove the stigmas of race and nation from Jewish artists, dealers, and collectors, and instead see their contribution to a community of spirit. "Anti-Semitism and xenophobia, aside from being monstrosities on the human level, are indicators of the fragility and spiritual poverty of a nation. Indeed, how fragile is a race that intends to live exclusively within itself and fears any form of thought different from its own! The attraction of Paris has been equal to that of

Rome when Poussin went to stay there as a foreigner for the greatest benefit to his art and that of French painting. It is from its intellectual heterogeneity that Paris drew its vigor and sense of innovation."[15]

Brielle's argument was evidently not only in response to what was happening in Germany in 1933, but in response to a series of articles published at home in the mainstream magazines *L'Amour de l'art* and *L'Art vivant*. With great anxiety about the state of civilization in general and that of French art in particular – an anxiety exacerbated by the 1929 Wall Street crash – French critics had given free reign to their fears. Articles with titles such as "The Agony of Painting," "Do We Still Have a French Art?" and "The End of French Painting" repeatedly appeared in the press. Their argument, as Brielle indicated, was double-edged. While they cursed Jewish artists either for producing ugly, deformed, decadent art, or for producing a second-rate imitation of French art that had managed to usurp the legitimate place of truly French art, these critics cursed the French even more for having lost the vitality, the passion for life, the irrepressible hope against all odds that continued to inspire Jewish artists. The French School, which one had thought eternal and unassailable, they lamented, had revealed itself to be shamefully vulnerable. Foreign Jews and native Frenchmen were thus bound together for conservative critics in a pathological scenario.[16]

In 1947 the Galerie Charpentier, which had been one of the most active galleries during the collaborationist regime of Vichy (at a time when Jewish artists, most of them hiding in the countryside, were forbidden to exhibit in Paris), mounted a large exhibition, *One Hundred Masterpieces by the Painters of the School of Paris*. Celebrating the artists of the Circle of Montparnasse in this way was a way to make amends. The opening sentence of the catalogue, written by the critic Jacques Lassaigne, rehearsed once again the litany: *Existe-t-il un expressionisme français?* When Frenchmen were shown alongside Germans and Belgians in a Paris

exhibition only a few years back, he wrote, the show provoked a general outcry. Now Lassaigne argued in favor of Expressionism as a timeless and universal tendency in art. In the aftermath of World War II, in response to the horrors of the war and to Hitler's infamous concept of "degenerate art," Expressionism, and all the tortured anxiety that accompanied it, had now become for artists and critics alike a badge of honor.

Footnotes

1. On the occasion of the exhibition and its accompanying publication, *The Circle of Montparnasse: Jewish Artists in Paris, 1905-1945*, The Jewish Museum, New York, 1985, curated by Kenneth E. Silver and myself.

2. Billy Klüver and Julie Martin, *Kiki's Paris: Artists and Lovers 1900-1930* (New York: Harry N. Abrams, 1989), 28-29.

3. Ernest Hemingway, *A Moveable Feast*, published posthumously in 1964, deals with his memories of Paris from 1921 to 1926.

4. Fritz Vanderpyl, "Existe-t-il une peinture juive?" *Mercure de France*, July 15, 1925, 386-96.

5. Adolphe Basler, "Y-a-t-il une peinture juive?" Ibid., November 15, 1925, 11-18.

6. Elie Faure, *Soutine* (Paris: Crès, 1929), 8-9.

7. Florent Fels, *L'Art moderne de 1900 à nos jours* (Paris: Pierre Cailler, 1956), 120.

8. See Faure, *Soutine*, and Waldemar George, *Soutine* (Paris: Le Triangle, 1928). For a longer discussion of this problem, see my essay "From *Fin-de-Siècle* to Vichy: The Cultural Hygienics of Camille (Faust) Mauclair," in *The Jew in the Text*, ed. Linda Nochlin and Tamar Garb (London: Thames and Hudson, 1995), 156-73.

9. This was Jacques Lassaigne's opening sentence in his catalogue essay for *Cents chefs d'oeuvre des peintres de l'Ecole française* at the Galerie Charpentier in 1947.

10. On this subject, see Marit Werenskiold, *The Concept of Expressionism: Origins and Metamorphoses* (Oslo: Universitetsforlaget, 1984). On the fascinating question of the differentiating task of art history, see also Jean-Claude Lebensztejn's essay on Fauvism vs. Expressionism (based on a much earlier and unpublished essay written on the occasion of the exhibition *Le Fauvisme et les débuts de l'Expressionisme allemand*, held at the Musée National d'art moderne in 1967), in *Annexes–de l'oeuvre d'art: Sol* (Paris: Editions de la Part de l'Oeil, 1999).

11. Cited in Werenskiold, p. 75. The exhibition was held at the Galerie Alice Manteau.

12. André Breton, *Surrealism and Painting* (New York: Icon Editions, 1928), 2-3. Italics in original.

13. Louis Aragon, *La Peinture au défi*, 1930, catalogue of the *Exposition de collages*, held at the Galerie Goemans in Paris. My translation. Sections of Aragon's essay have been published in English translation by Lucy Lippard in *Surrealists on Art* (New York: Prentice Hall, 1970), 36-50.

14. The two main exceptions that come to mind are *The Revolution*, 1937 (formerly in the artist's collection) and *White Crucifixion*, 1938 (The Art Institute of Chicago).

15. Roger Brielle, "Les Peintres juifs: Modigliani et l'inquiétude nostalgique," *L'Amour de l'art*, September 1, 1933, 430-31.

16. See Georges Rivière, "Avons-nous encore un art français?" *L'Art vivant*, September 15, 1930, 721-22; Jacques-Émile Blanche, "La Fin de la peinture française," Ibid., excerpt, *Fond Vauxelles*, Paris, 1931, 297-98; Elie Faure, "L'Agonie de la peinture," *L'Amour de l'art*, June 1, 1931, 231-38. For a more detailed discussion of this type of rhetoric, see my essay, "The *Ecole Française* vs. the *Ecole de Paris*: The Debate about the Status of Jewish Artists in Paris between the Wars," in *The Circle of Montparnasse* catalogue.

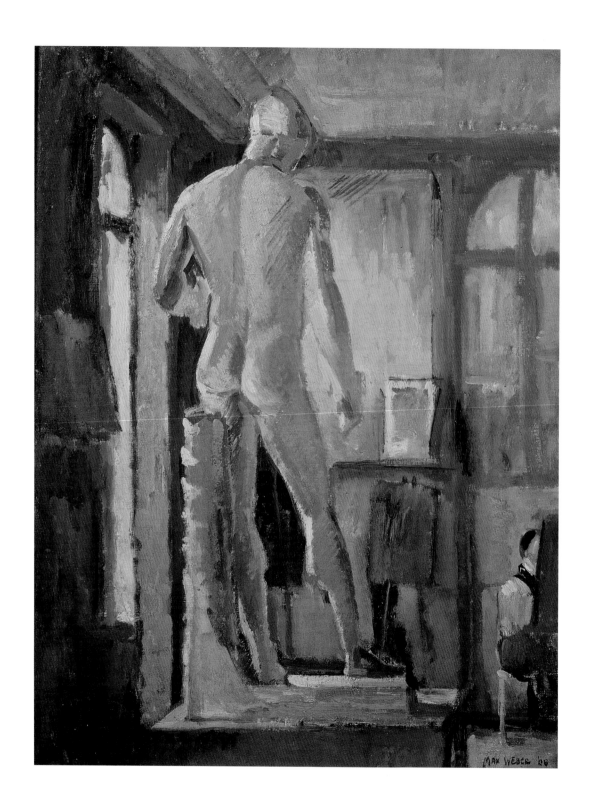

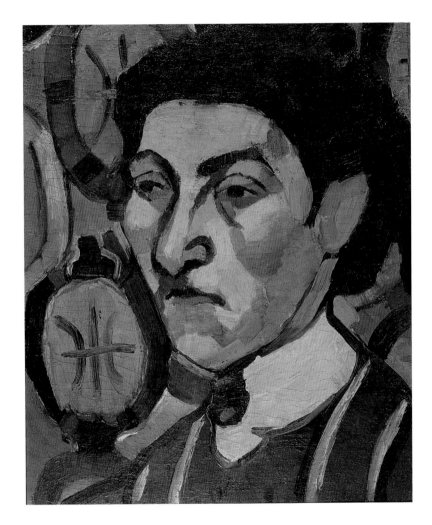

2. **Sonia Delaunay**
Philomène, 1907
Oil on canvas, 16 x 13 in. (40.6 x 33 cm)
Anonymous Lender

OPPOSITE:

1. **Max Weber**
The Apollo in the Matisse Academy, 1908
Oil on canvas, 23 x 18 in. (58.4 x 45.7 cm)
Max Weber Estate, Courtesy of
Gerald Peters Gallery, New York

3. **Jules Pascin**
The Turkish Family, 1907
Oil on canvas, 24 x 20 in. (61 x 50.8 cm)
Paulette and Kurt Olden

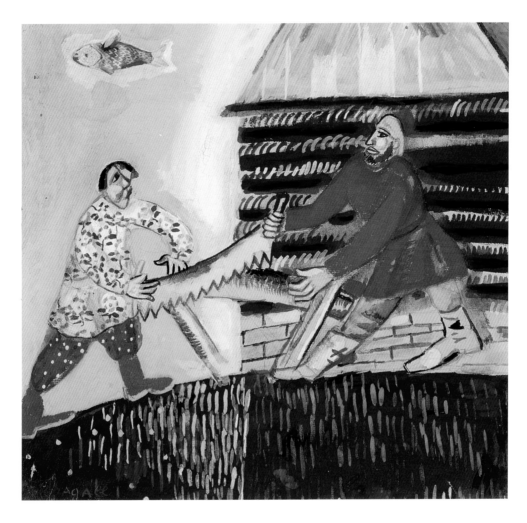

4. **Marc Chagall**
Carpenters and Fish, 1912
Gouache on paper, 13 3/4 x 13 in. (34.9 x 33 cm)
Private Collection

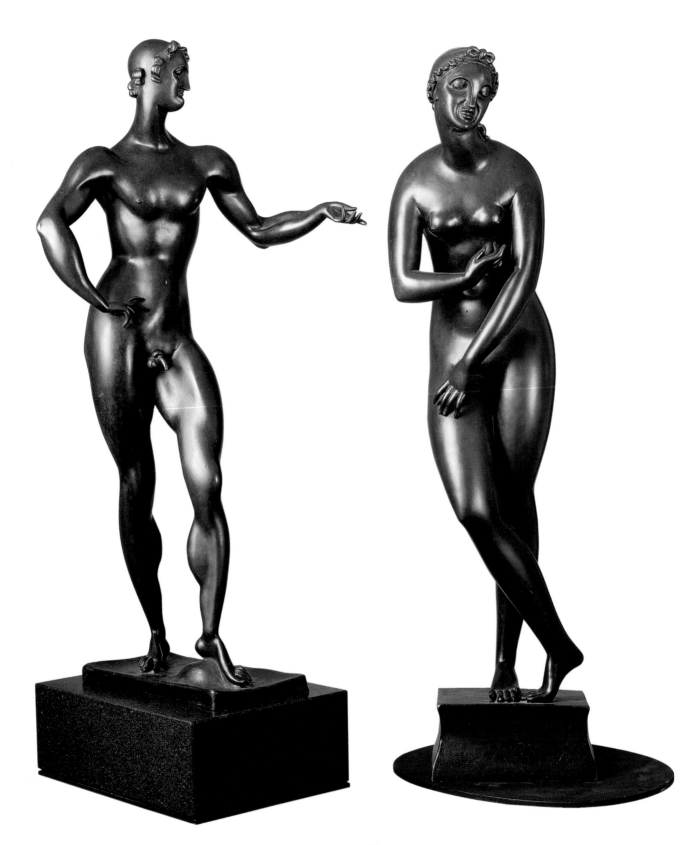

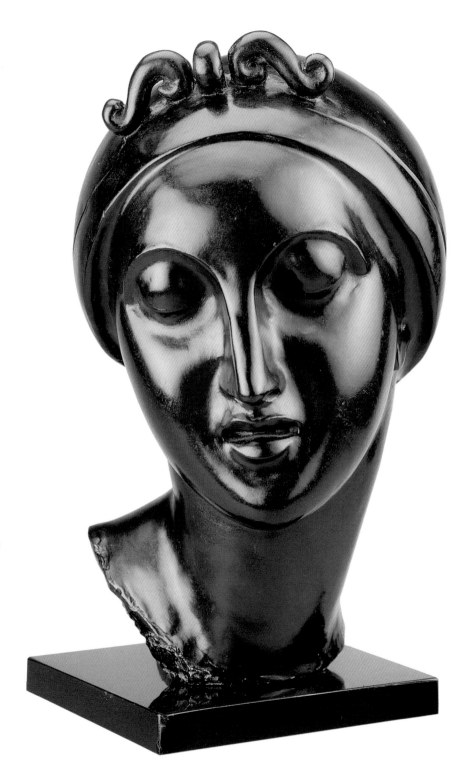

OPPOSITE:

5. Elie Nadelman
Left: Standing Male Nude, ca. 1908-09
Bronze, 25½ x 12 x 9½ in.
(64.8 x 30.5 x 24.1 cm)
Private Collection
Right: Standing Nude Figure, ca. 1907
Bronze, 29¼ x 6½ x 6 in.
(74.3 x 16.5 x 15.2 cm)
Private Collection

RIGHT:

6. Elie Nadelman
Ideal Head, ca. 1908
Bronze, 13 in. (33 cm) high
Private Collection

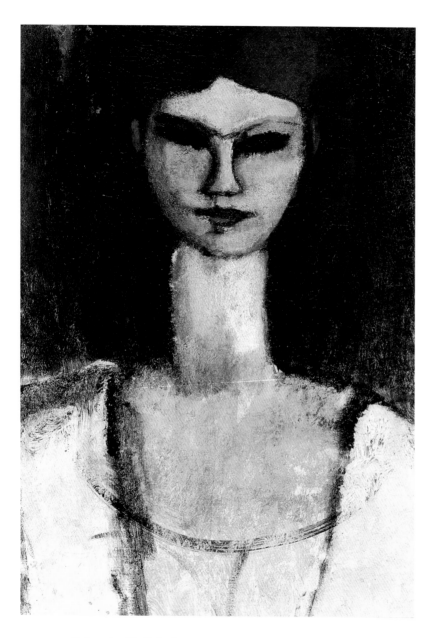

7. **Amedeo Modigliani**
Buste de Jeune Femme (Bust of a Young Woman), 1911
Oil on canvas, 21⅝ x 14 15/16 in. (55 x 38 cm)
Frances and Bernard Laterman

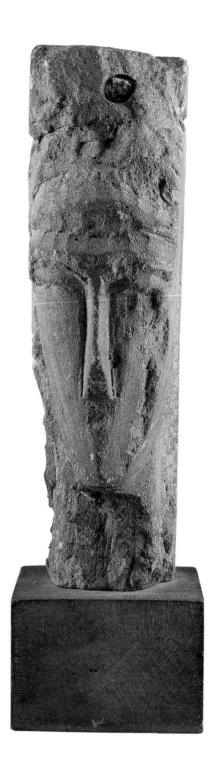

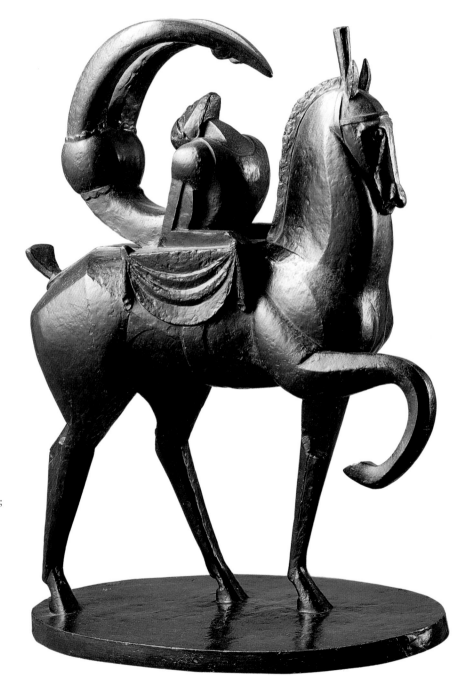

OPPOSITE:

8. Amedeo Modigliani
Tête (Head), 1911-12
Limestone, 16 7/16 x 4 15/16 x
6 11/16 in.(41.8 x 12.5 x 17 cm);
base 4¼ x 6 x 6 in.
(10.8 x 15.2 x 15.2 cm)
The Henry and Rose Pearlman
Foundation, Inc.

RIGHT:

9. Jacques Lipchitz
Acrobat on Horseback, 1914
Bronze, 21¾ in. (55.2 cm) high
Private Collection

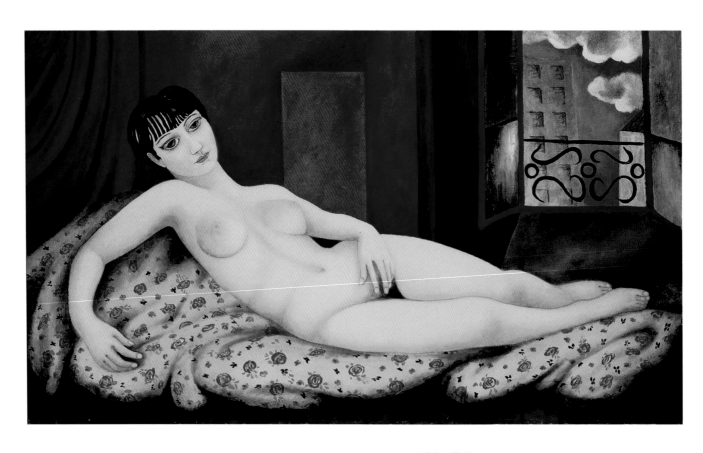

10. **Moïse Kisling**
Grand nu allongé, Kiki (Large Reclining Nude, Kiki), 1924
Oil on canvas, 25½ x 43¼ in. (65 x 110 cm)
Private collection, Courtesy of
American-European Art Associates

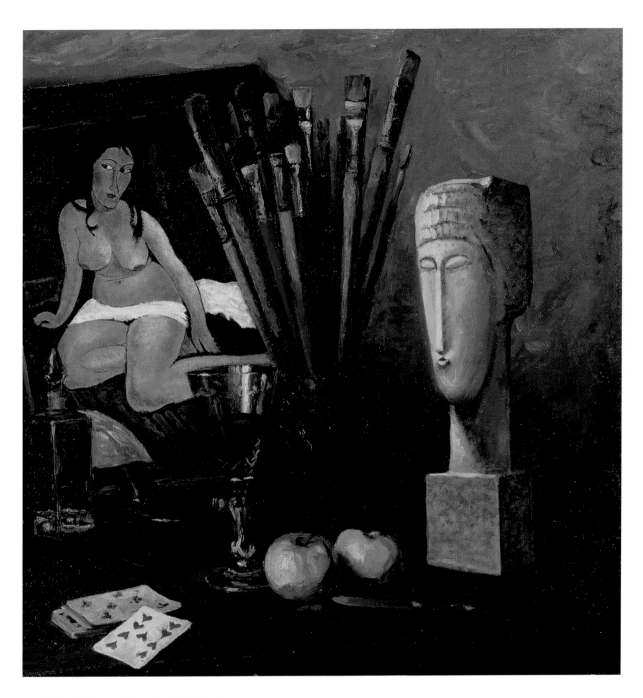

11. Moïse Kisling and Amedeo Modigliani
Atelier de Kisling avec des oeuvres de Modigliani
(Studio of Kisling with Works by Modigliani), 1918
Oil on canvas, 26 x 25 in. (66 x 63.5 cm)
Private collection, Courtesy of
American-European Art Associates

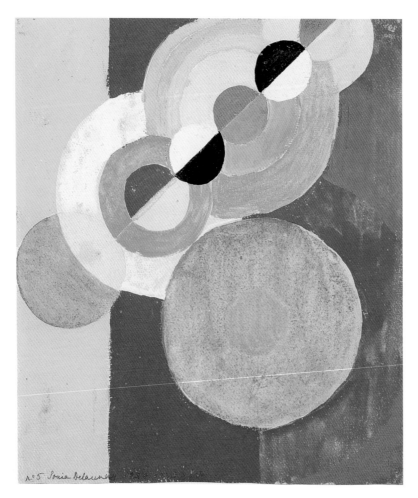

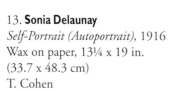

12. Sonia Delaunay
Rythme No. 5, 1939
Gouache on paper, 10⅝ x 9 in.
(27 x 22.9 cm)
T. Cohen

13. Sonia Delaunay
Self-Portrait (Autoportrait), 1916
Wax on paper, 13¼ x 19 in.
(33.7 x 48.3 cm)
T. Cohen

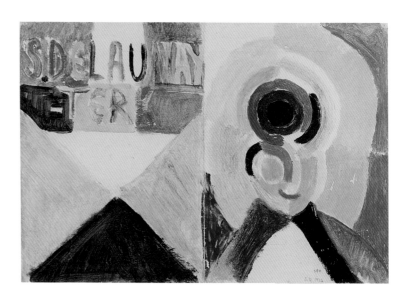

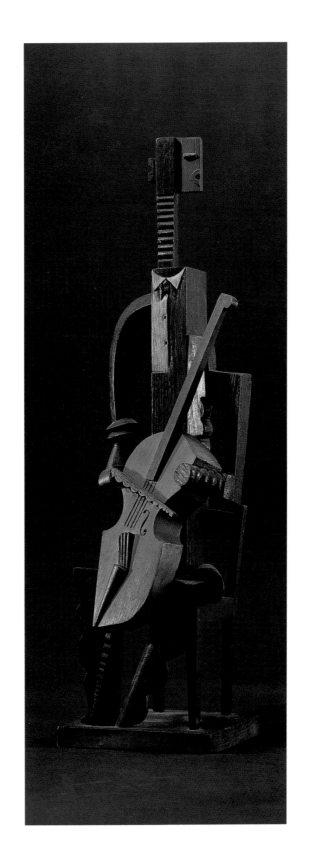

14. Jacques Lipchitz
Detachable Figure: Seated Musician, 1915
Painted wood, 19¾ in. (50.2 cm) high
Private Collection

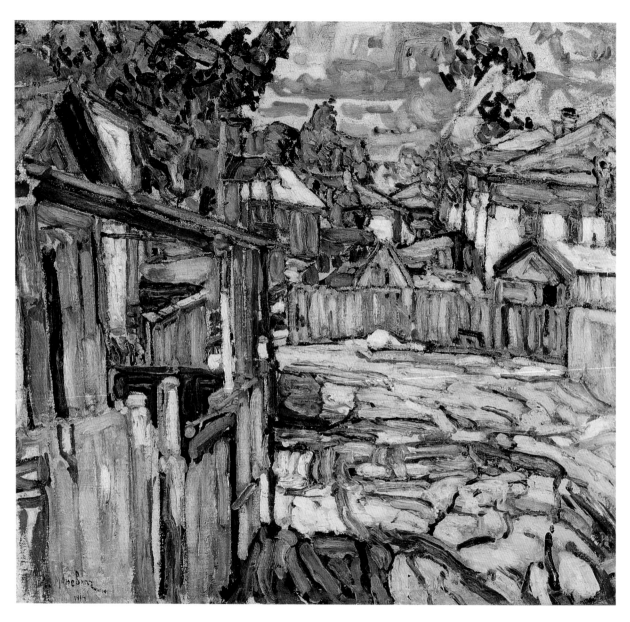

15. **Mané-Katz**
Landscape, 1914
Oil on canvas, 23½ x 26½ in. (59.1 x 67.3 cm)
The Jewish Museum, New York.
The Rose and Benjamin Mintz Collection, M1001

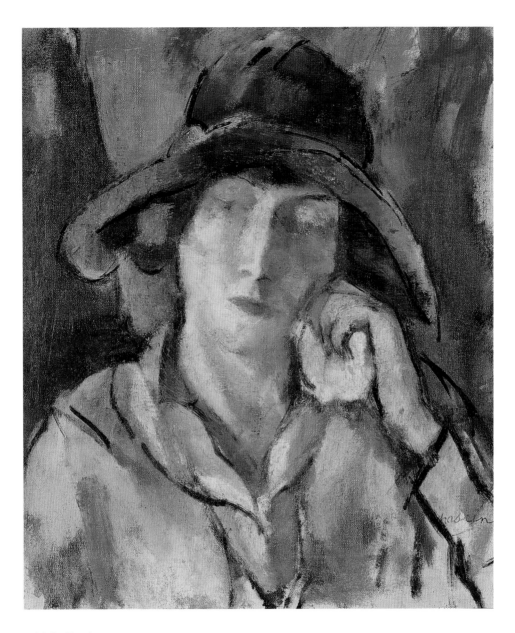

16. **Jules Pascin**
Hermine in a Blue Hat, 1918
Oil on canvas, 17⅞ x 15⅝ in. (45.4 x 39.7 cm)
Private collection, Tel Aviv and New York

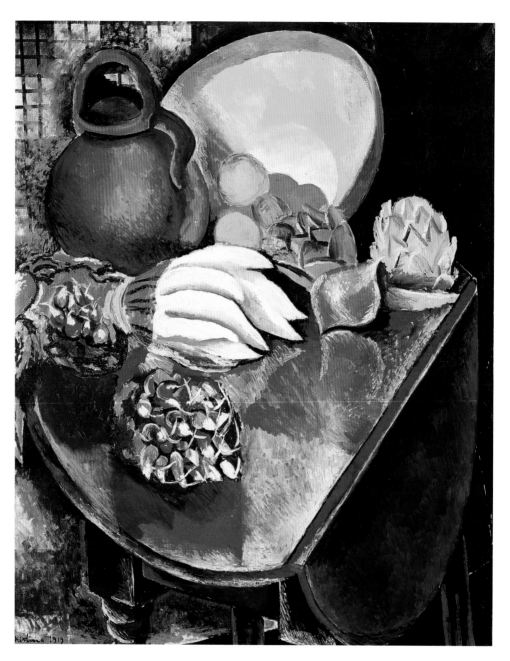

17. **Moïse Kisling**
Pineapples and Pitcher, 1919
Oil on canvas, 36¼ x 28¾ in. (92.1 x 73 cm)
Private Collection

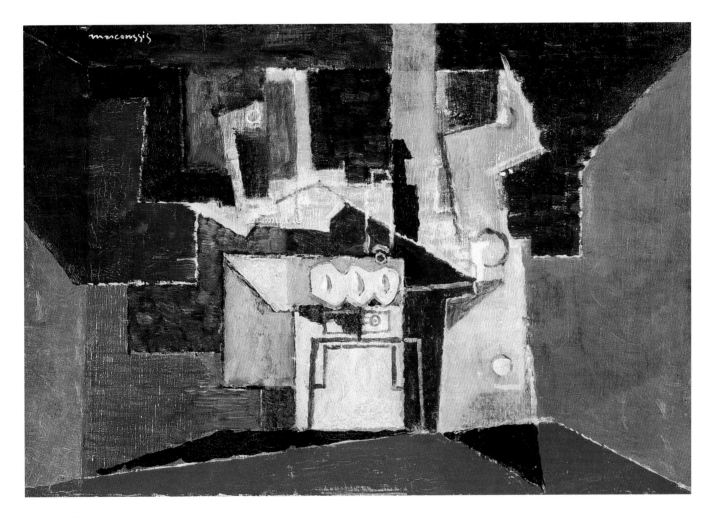

18. **Louis Marcoussis**
La Cuisine, 1928
Oil on canvas, 15 x 21½ in. (38.1 x 55.2 cm)
Blanche and Romie Shapiro

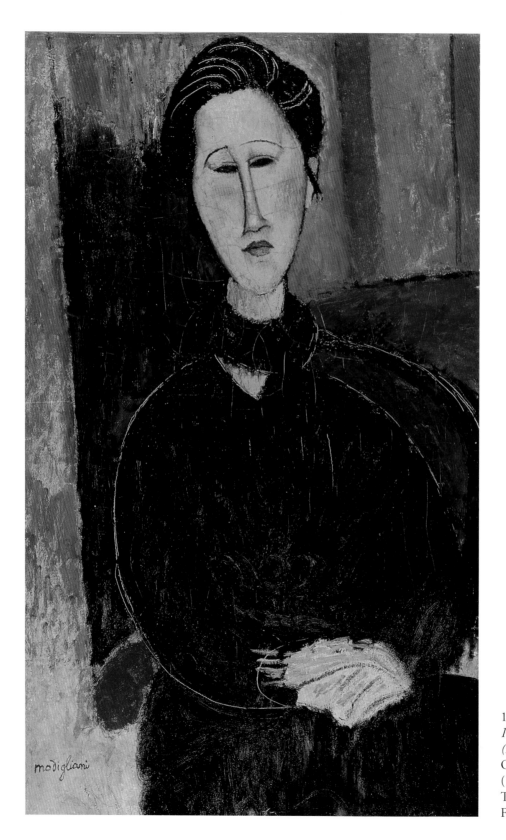

19. **Amedeo Modigliani**
*Portrait of Anna
(Hanka) Zborowska*, 1916
Oil on canvas, 42 x 28 in.
(106.6 x 71 cm)
The Alex Hillman
Family Foundation

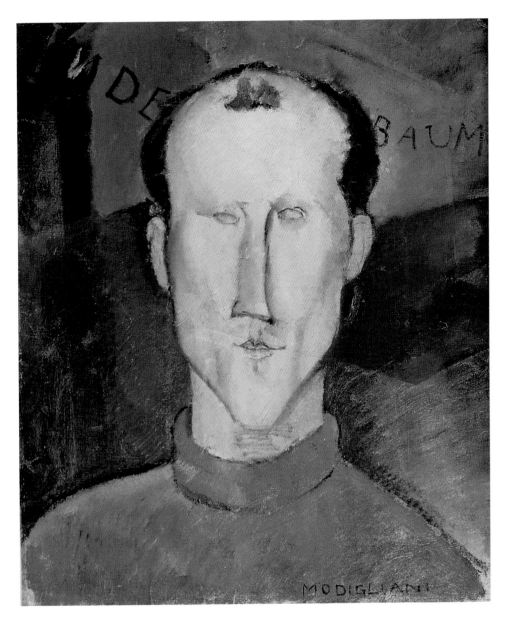

20. Amedeo Modigliani
Portrait of Léon Indenbaum, 1915
Oil on canvas, 21½ x 18 in. (54.6 x 45.7 cm)
The Henry and Rose Pearlman Foundation, Inc.

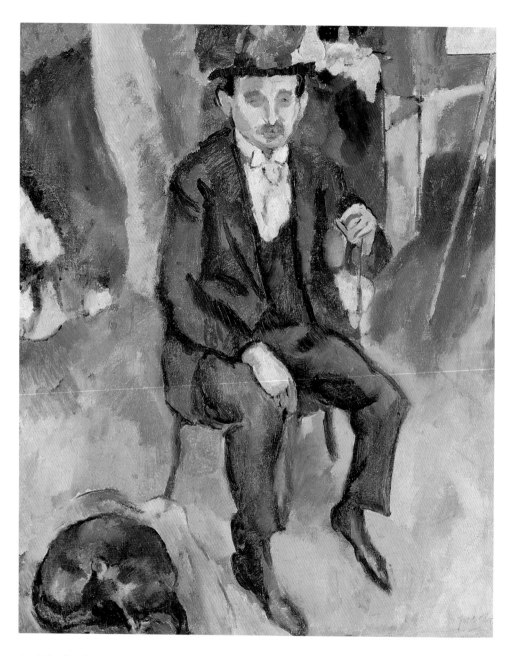

21. Jules Pascin
German Painter with Dog in the Studio, 1922
Oil on canvas, 27½ x 22½ in. (69.9 x 57.2 cm)
Malka and Mannes Schwarz, New York

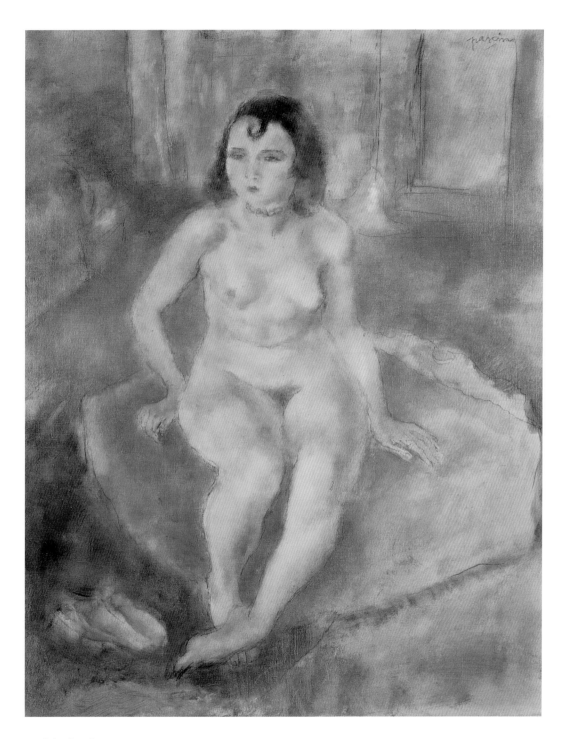

22. **Jules Pascin**
Femme assise (Seated Woman), 1929
Oil on canvas, 35 x 28 in. (88.9 x 71.1 cm)
The Jewish Museum, New York.
Gift of the Muriel and William Rand Collection, 1994-702

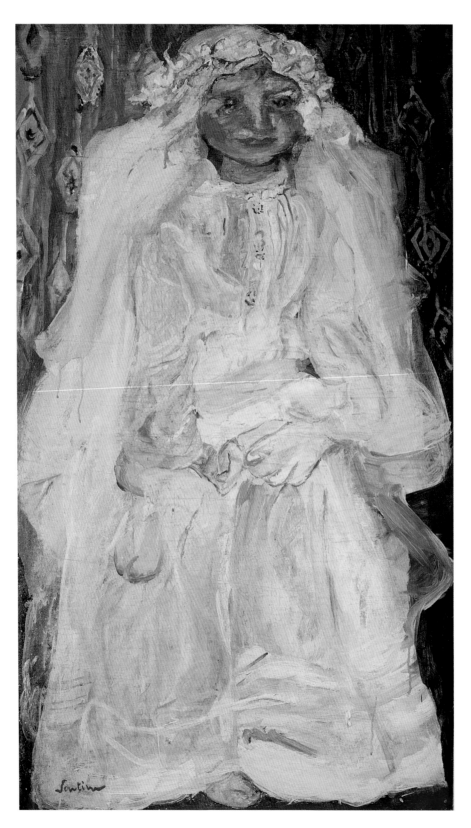

23. **Chaim Soutine**
The Communicant, ca. 1924
Oil on canvas,
31⅞ x 18⅞ in.
(81 x 47.9 cm)
The Whitehead Collection
(Courtesy Achim Moeller
Fine Art, New York)

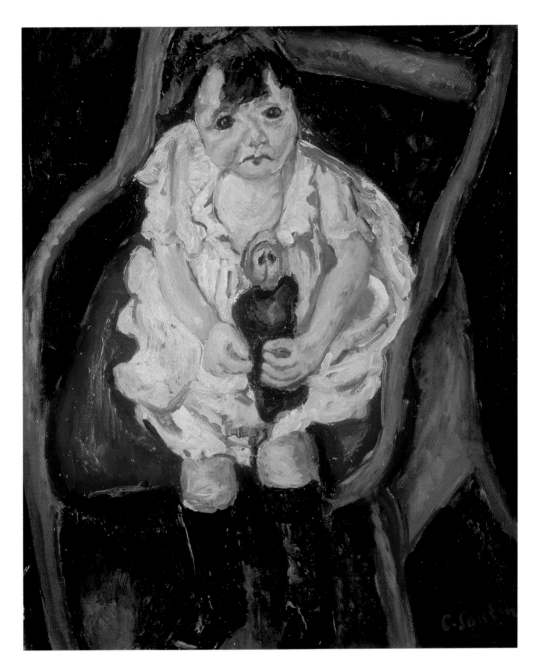

24. **Chaim Soutine**
Little Girl with a Doll, 1920
Oil on canvas, 28¾ x 23½ in. (73 x 59.7 cm)
The Alex Hillman Family Foundation

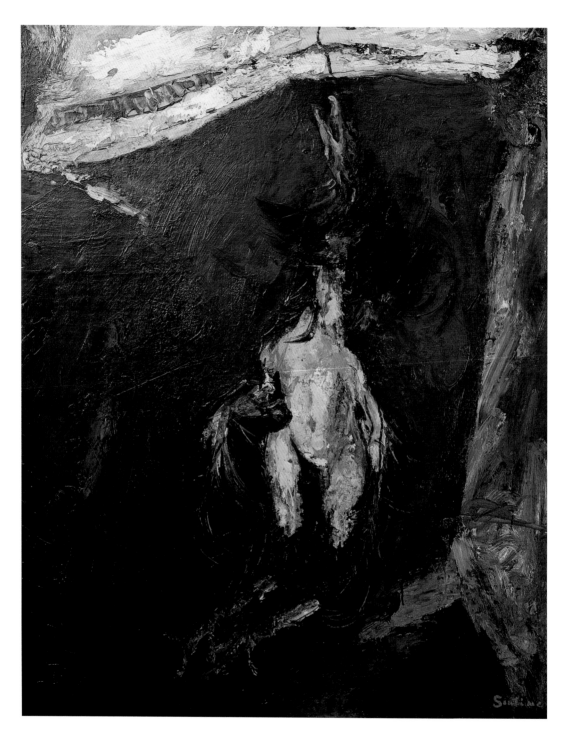

25. **Chaim Soutine**
Hanging Turkey, ca. 1925
Oil on canvas, 36 x 28⅞ in. (91.4 x 72.4 cm)
Richard S. Zeisler Collection, New York

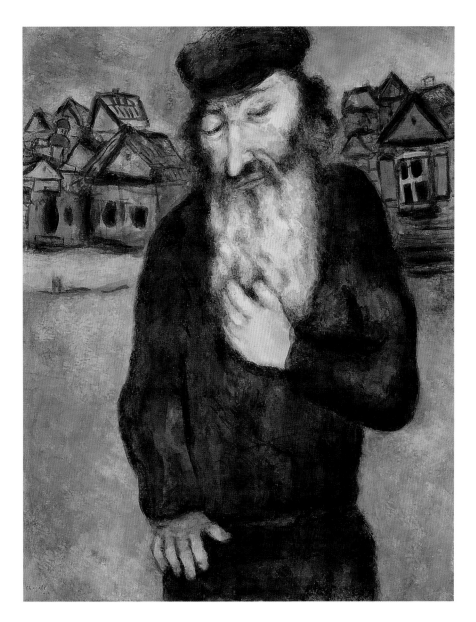

26. **Marc Chagall**
Rabbi, ca. 1931
Gouache and watercolor over charcoal
or graphite on paper mounted on panel,
24⅝ x 19⅝ in. (62.5 x 49.8 cm)
The Jewish Museum, New York. Partial gift and bequest of
Frances Gershwin Godowsky and family in honor of
George Gershwin, 1999-77

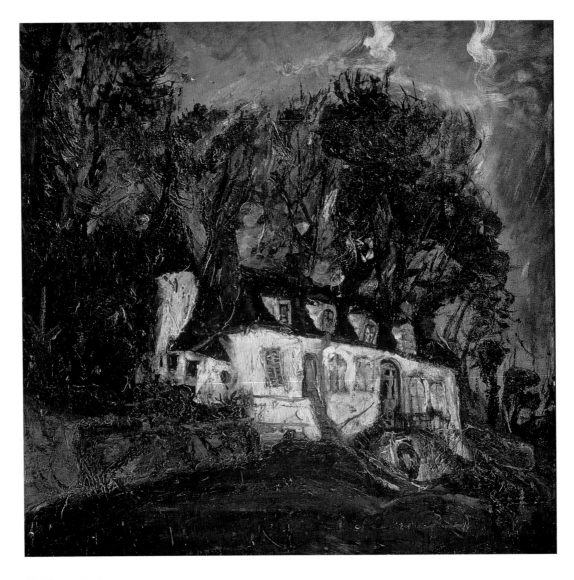

27. **Chaim Soutine**
House at Oisème, ca. 1936
Oil on canvas, 26 x 26 13/16 in. (66 x 68 cm)
Private Collection

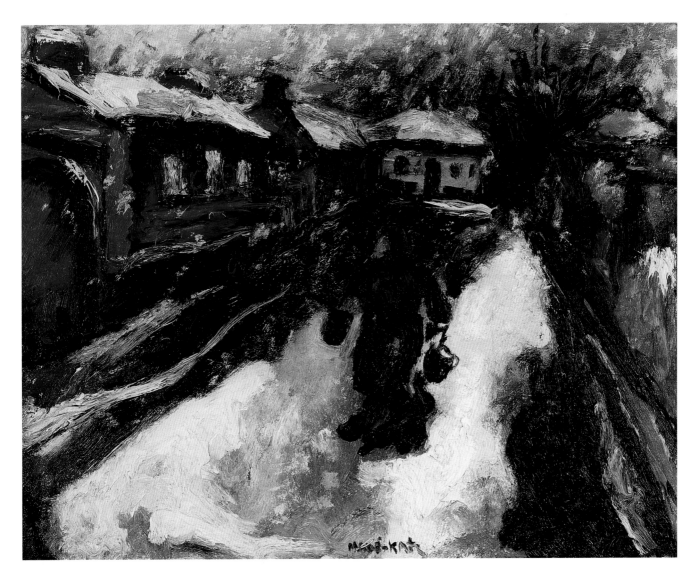

28. **Mané-Katz**
Russian Shtetl, 1931
Oil on canvas, 25¾ x 31⅞ in. (63.5 x 81 cm)
The Jewish Museum, New York. Gift of Norman and Lois Barbanell Rosen, 1981-329

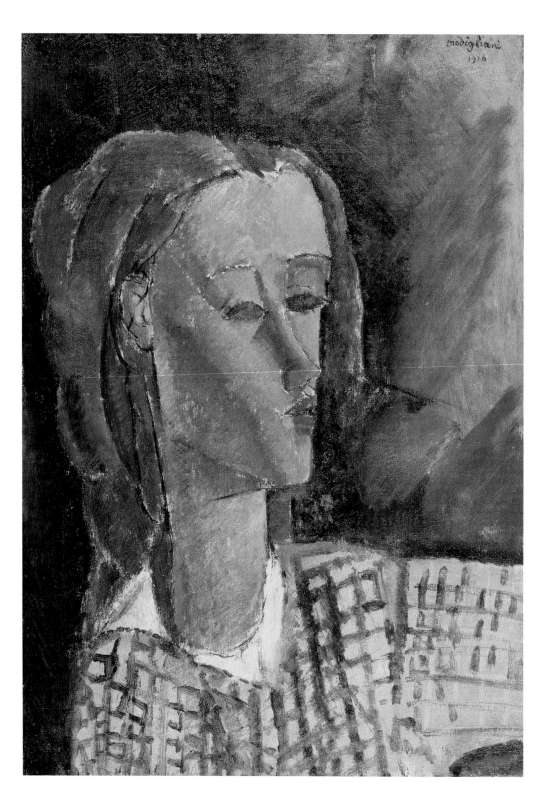

29. **Amedeo Modigliani**
Portrait of Beatrice Hastings,
ca. 1916
Oil on canvas,
16 15/16 x 10⅝ in.
(43 x 27 cm)
The Whitehead Collection
(Courtesy Achim Moeller
Fine Art, New York)

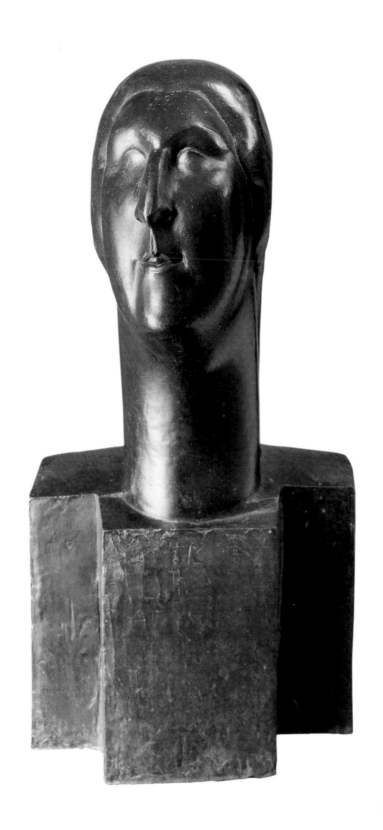

Fig. 10
Chana Orloff
Tête de femme, ca. 1925
Bronze, 24 in. (61 cm) high
Private Collection

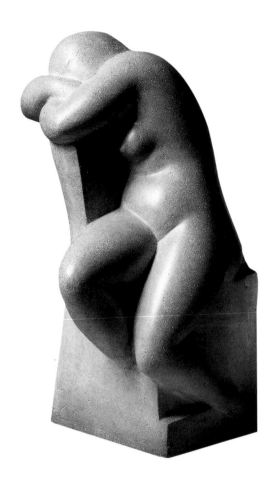

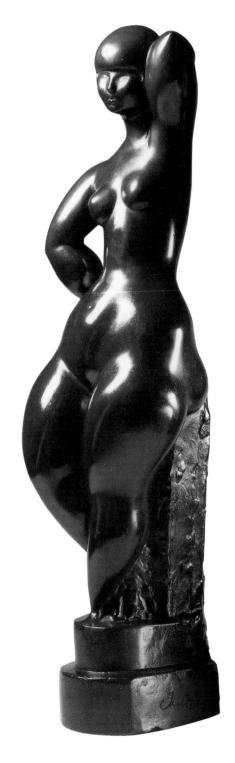

ABOVE:

Fig. 11
Chana Orloff
Nude Seated in an Armchair, 1927
Stone, 16¼ in. (41.3 cm) high
Private collection, Tel Aviv and New York

RIGHT:

Fig. 12
Chana Orloff
Standing Nude, 1925
Bronze, 24 in. (61 cm) high
Private collection,
Tel Aviv and New York

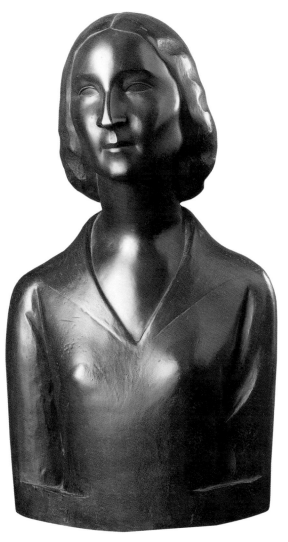

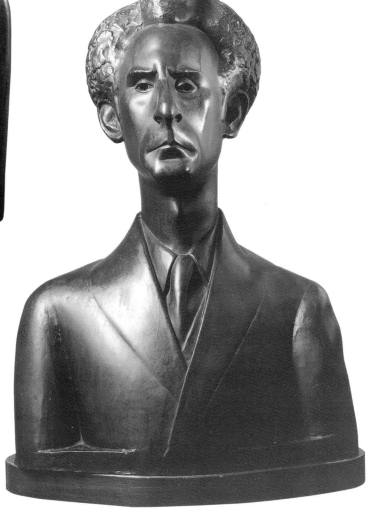

ABOVE:

Fig. 13
Chana Orloff
Portrait of Madame Peretz Hirshbein, 1924
Bronze, 23½ in. (59.7 cm) high
The Jewish Museum, New York.
Gift of Erich Cohn, JM 91-64

RIGHT:

Fig. 14
Chana Orloff
Portrait of Peretz Hirshbein, 1924
Bronze, 25 x 18 x 11 in. (63.5 x 45.7 x 27.9 cm)
Collection of Mr. and Mrs. Omus Hirshbein

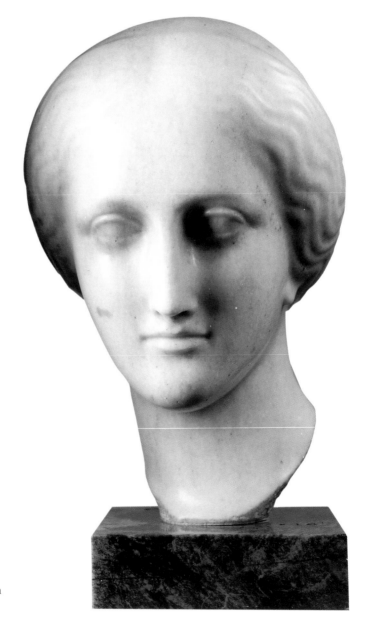

Fig. 15
Elie Nadelman
Classical Head, ca. 1910
Marble, 13 in. (33 cm) high
Private Collection

Catalogue of the Exhibition

1.

Marc Chagall
Carpenters and Fish, 1912
Gouache on paper,
13¾ x 13 in. (34.9 x 33 cm)
Private Collection
(Color plate 4)

2.

Marc Chagall
Rabbi, ca. 1931
Gouache and watercolor over
charcoal or graphite on paper
mounted on panel,
24⅝ x 19⅝ in. (62.5 x 49.8 cm)
The Jewish Museum, New York.
Partial gift and bequest of Frances
Gershwin Godowsky and family
in honor of George Gershwin,
1999-77
(Color plate 26)

3.

Sonia Delaunay
Philomène, 1907
Oil on canvas, 16 x 13 in.
(40.6 x 33 cm)
Anonymous Lender
(Color plate 2)

4.

Sonia Delaunay
Self-Portrait (Autoportrait), 1916
Wax on paper, 13¼ x 19 in.
(33.7 x 48.3 cm)
T. Cohen
(Color plate 13)

5.

Sonia Delaunay
Rythme No. 5, 1939
Gouache on paper, 10⅝ x 9 in.
(27 x 22.9 cm)
T. Cohen
(Color plate 12)

6.

**Moïse Kisling and
Amedeo Modigliani**
*Atelier de Kisling avec des oeuvres
de Modigliani (Studio of Kisling
with Works by Modigliani)*, 1918
Oil on canvas, 26 x 25 in.
(66 x 63.5 cm)
Private collection, Courtesy of
American-European Art
Associates
(Color plate 11)

7.

Moïse Kisling
Pineapples and Pitcher, 1919
Oil on canvas, 36¼ x 28¾ in.
(92.1 x 73 cm)
Private Collection
(Color plate 17)

8.

Moïse Kisling
*Grand nu allongé, Kiki (Large
Reclining Nude, Kiki)*, 1924
Oil on canvas, 25½ x 43¼ in.
(65 x 110 cm)
Private collection, Courtesy of
American-European Art
Associates
(Color plate 10)

9.

Jacques Lipchitz
Horsewoman with Fan, 1913
Bronze, 26¾ x 7¼ x 7¾ in.
(67.9 x 18.4 x 19.7 cm)
Courtesy of Marlborough
Gallery, New York
(Fig. 1)

10.

Jacques Lipchitz
Spanish Dancer, 1914
Bronze, 29 in. (73.7 cm) high
Private Collection
(Fig. 2)

11.

Jacques Lipchitz
Acrobat on Horseback, 1914
Bronze, 21¾ in. (55.2 cm) high
Private Collection
(Color plate 9)

12.

Jacques Lipchitz
*Detachable Figure:
Seated Musician*, 1915
Painted wood, 19¾ in.
(50.2 cm) high
Private Collection
(Color plate 14)

13.

Mané-Katz
Landscape, 1914
Oil on canvas, 23½ x 26½ in.
(59.1 x 67.3 cm)
The Jewish Museum, New York.
The Rose and Benjamin Mintz
Collection, M1001
(Color plate 15)

14.
Mané-Katz
Russian Shtetl, 1931
Oil on canvas, 25¾ x 31⅞ in.
(63.5 x 81 cm)
The Jewish Museum, New York.
Gift of Norman and Lois
Barbanell Rosen, 1981-329
(Color plate 28)

15.
Louis Marcoussis
La Cuisine, 1928
Oil on canvas, 15 x 21½ in.
(38.1 x 55.2 cm)
Blanche and Romie Shapiro
(Color plate 18)

16.
Amedeo Modigliani
Buste de Jeune Femme
(Bust of a Young Woman), 1911
Oil on canvas,
21⅝ x 14 15/16 in. (55 x 38 cm)
Frances and Bernard Laterman
(Color plate 7)

17.
Amedeo Modigliani
Tête (Head), 1911-12
Limestone, 16 7/16 x 4 15/16 x 6
11/16 in. (41.8 x 12.5 x 17 cm);
base 4¼ x 6 x 6 in.
(10.8 x 15.2 x 15.2 cm)
The Henry and Rose Pearlman
Foundation, Inc.
(Color plate 8)

18.
Amedeo Modigliani
Portrait of Léon Indenbaum, 1915
Oil on canvas, 21½ x 18 in.
(54.6 x 45.7 cm)
The Henry and Rose Pearlman
Foundation, Inc.
(Color plate 20)

19.
Amedeo Modigliani
Portrait of Anna (Hanka)
Zborowska, 1916
Oil on canvas, 42 x 28 in.
(106.6 x 71 cm)
Lent by The Alex Hillman
Family Foundation
(Color plate 19)

20.
Amedeo Modigliani
Portrait of Beatrice Hastings,
ca. 1916
Oil on canvas, 16 15/16 x 10⅝
in. (43 x 27 cm)
The Whitehead Collection
(Courtesy Achim Moeller
Fine Art, New York)
(Color plate 29)

21.
Elie Nadelman
Standing Nude Figure, ca. 1907
Bronze, 29¼ x 6½ x 6 in.
(74.3 x 16.5 x 15.2 cm)
Private Collection
(Color plate 5)

22.
Elie Nadelman
Ideal Head, ca. 1908
Bronze, 13 in. (33 cm) high
Private Collection
(Color plate 6)

23.
Elie Nadelman
Standing Male Nude, ca. 1908-9
Bronze, 25½ x 12 x 9½ in.
(64.8 x 30.5 x 24.1 cm)
Private Collection
(Color plate 5)

24.
Elie Nadelman
Classical Head, ca. 1910
Marble, 13 in. (33 cm) high
Private Collection
(Fig. 15)

25.
Chana Orloff
Portrait of Madame Peretz
Hirshbein, 1924
Bronze, 23½ in. (59.7 cm) high
The Jewish Museum, New York.
Gift of Erich Cohn, JM 91-64
(Fig. 13)

26.
Chana Orloff
Portrait of Peretz Hirshbein, 1924
Bronze, 25 x 18 x 11 in.
(63.5 x 45.7 x 27.9 cm)
Collection of Mr. and Mrs.
Omus Hirshbein
(Fig. 14)

27.
Chana Orloff
Standing Nude, 1925
Bronze, 24 in. (61 cm) high
Private collection, Tel Aviv and
New York
(Fig. 12)

28.
Chana Orloff
*Tête de Femme
(Head of a Woman)*, ca. 1925
Bronze, 24 in. (61 cm) high
Private Collection
(Fig. 10)

29.
Chana Orloff
Nude Seated in an Armchair, 1927
Stone, 16¼ in. (41.3 cm) high
Private collection, Tel Aviv and
New York
(Fig. 11)

30.
Jules Pascin
The Turkish Family, 1907
Oil on canvas, 24 x 20 in.
(61 x 50.8 cm)
Paulette and Kurt Olden
(Color plate 3)

31.
Jules Pascin
Hermine in a Blue Hat, 1918
Oil on canvas, 17⅞ x 15⅝ in.
(45.4 x 39.7 cm)
Private collection, Tel Aviv
and New York
(Color plate 16)

32.
Jules Pascin
*German Painter with Dog in the
Studio*, 1922
Oil on canvas, 27½ x 22½ in.
(69.9 x 57.2 cm)
Malka and Mannes Schwarz,
New York
(Color plate 21)

33.
Jules Pascin
Femme assise (Seated Woman),
1929
Oil on canvas, 35 x 28 in.
(88.9 x 71.1 cm)
The Jewish Museum, New York.
Gift of the Muriel and William
Rand Collection, 1994-702
(Color plate 22)

34.
Chaim Soutine
Little Girl with a Doll, 1920
Oil on canvas, 28¾ x 23½ in.
(73 x 59.7 cm)
Lent by The Alex Hillman
Family Foundation
(Color plate 24)

35.
Chaim Soutine
The Communicant, ca. 1924
Oil on canvas, 31⅞ x 18⅞ in.
(81 x 47.9 cm)
The Whitehead Collection
(Courtesy Achim Moeller
Fine Art, New York)
(Color plate 23)

36.
Chaim Soutine
Hanging Turkey, ca. 1925
Oil on canvas, 36 x 28½ in.
(91.4 x 72.4 cm)
Richard S. Zeisler Collection,
New York
(Color plate 25)

37.
Chaim Soutine
House at Oisème, ca. 1936
Oil on canvas, 26 x 26 13/16 in.
(66 x 68 cm)
Private Collection
(Color plate 27)

38.
Max Weber
*The Apollo in the
Matisse Academy*, 1908
Oil on canvas, 23 x 18 in.
(58.4 x 45.7 cm)
Max Weber Estate, Courtesy of
Gerald Peters Gallery, New York
(Color plate 1)

Artist Biographies

Marc Chagall (1887–1985)

Marc Chagall, né Segal, was born in Vitebsk, Russia, the eldest of nine children of a Hasidic family. He attended *heder*, or traditional Jewish school, and then the local Russian high school, where he studied painting. Chagall began his art studies in Yehuda Pen's studio, concurrently earning money by retouching photographic negatives. From 1907 to 1910, he lived in St. Petersburg and studied first with Nicholas Roerich and later at the Zvantseva, a school run by Léon Bakst. Chagall's ambition propelled him to Paris. In 1910, a patron helped to fund his further education at the academies of La Palette – with instructors Henri Le Fauconnier and André Dunoyer de Segonzac – and La Grande Chaumière. He visited galleries, salons, and museums and discovered a passion for Eugène Delacroix, Théodore Géricault, Gustave Courbet, Jean-François Millet, Rembrandt, the Brothers Le Nain, Jean Fouquet, Jean-Baptiste Chardin, Antoine Watteau, and Paolo Uccello. Chagall was introduced to Auguste Renoir and the Impressionists at Durand-Ruel's gallery and Vincent Van Gogh, Paul Gauguin, and Henri Matisse at Bernheim-Jeune's. He was inspired by the artistic climate of Paris, but his life in Russia shaped the subject matter of his work. From 1912 until he left Paris in 1914, Chagall rented a studio in La Ruche, a residence shared by other artists including Fernand Léger, Alexander Archipenko, Amedeo Modigliani, and Chaim Soutine. He was part of various art circles in which discussion was centered on the Cubist and Futurist movements. His connection to Robert Delaunay and others enabled him to exhibit at the 1912 Salon d'Automne. Chagall also befriended many avant-garde poets, including Blaise Cendrars, Max Jacob, and Guillaume Apollinaire. In 1914, Chagall traveled to Berlin and then to Vitebsk, where he remained due to the outbreak of World War I. He married Bella Rosenfeld in 1915. In Russia, Chagall was appointed Commissar for the Arts in Vitebsk in 1918 and founded a museum and an art school. He and his wife and daughter, Ida, moved to Berlin in 1922, where he took up etching, a skill that provided enough money for the Chagalls to return to Paris in 1923. In Paris, Chagall extended his artistic production to include book illustration. Among other texts, he contributed images to editions of Nikolay Gogol's *Les Âmes mortes*, La Fontaine's *Fables*, and *The Bible*. Although he became a French citizen in 1937, Chagall and his wife fled France for the United States in 1941, remaining there until 1948. Bella Chagall died in the United States of a viral infection in 1944. Chagall continued to collaborate on theatrical productions while in New York, creating backdrops for the New York Ballet Theater. The Museum of Modern Art organized Chagall's first retrospective in 1946, which, along with major exhibitions in Paris, solidified his international reputation. Chagall settled in Saint-Paul-de-Vence in 1950 with his second wife, Valentina. He continued to paint mural designs for the theater, including the Paris Opéra in 1964 and the Metropolitan Opera in 1967. In the last thirty years of his life, Chagall explored the medium of stained glass and created windows for cathedrals in Metz and Reims, the Art Institute of Chicago, and the synagogue of the Hebrew University Hadassah Medical Center in Jerusalem, among others. Chagall died at the age of ninety-seven in Saint-Paul-de-Vence.

Sonia Delaunay (1885–1979)

Born in the Ukraine, Sonia Delaunay, née Stern, was adopted at the age of five by her maternal uncle, Henri Terk, a wealthy lawyer and art collector from St. Petersburg. When she was fourteen, she received her first box of paints from the artist Max Liebermann, who was a friend of her uncle. From 1903 to 1905, she studied drawing at the academy in Karlsruhe, Germany. In 1905, she arrived in Paris, living at first with Russian friends and subsequently establishing a studio in Montparnasse. She enrolled at the Académie de la Palette and also studied printmaking with Rudolf Grossmann. Delaunay's first one-woman show was held at Wilhelm Uhde's Galerie Notre-Dame-des-Champs in Montparnasse in 1908. The following year, she entered into a marriage of convenience with Uhde, who introduced her to Pablo Picasso, Georges Braque, Marc Chagall, Jules Pascin, and Robert Delaunay. In 1910 they divorced. That same year she married the artist Robert Delaunay, and together they explored the vocabulary of pure abstraction. Within two

years, Sonia Delaunay had produced her first studies of light (cast by the new electric street lamps) and had created collages and bookbindings in collaboration with the poets Blaise Cendrars, Guillaume Apollinaire, and Tristan Tzara. In the 1920s, she was acclaimed as a designer of theater, opera, and dance costumes for Serge Diaghilev, among others, and she purveyed her nonreferential, geometric designs in the fashion world. With the famous couturier, Jacques Heim, she participated in the Exposition Internationale des Arts Décoratifs et Industriels Modernes in 1925. With an engineer, she developed the neon sculpture *Zig Zag* for the Société d'Electricité de France in the 1930s. During World War II, Delaunay, by then a widow, joined Jean and Sophie Taeuber-Arp in Grasse; she returned to Paris in 1945, where she lived until her death. In 1953, the Galerie Bing in Paris held a major exhibition of her works. Five years later, the Städtisches Kunsthaus in Bielefeld, Germany, presented her with a one-woman exhibition. In 1967, the *Rétrospective Sonia Delaunay* was mounted at the Musée National d'Art Moderne in Paris. She was named Chevalier de la Légion d'Honneur in 1975. Delaunay died in Paris in 1979. The following year, the artist received a memorial retrospective at the Albright-Knox Gallery in Buffalo, New York.

Moïse Kisling (1891–1953)

The son of a Jewish tailor, Kisling was born in Kraków in 1891. Although his father wanted his son to become an engineer, Kisling attended the Warsaw Academy of Fine Arts. It was there that Kisling became enamored with France. Kisling arrived in Paris at the age of nineteen and lived first on the Rue des Beaux-Arts, then in Montmartre; by 1913, he had moved into a studio in Montparnasse. During those early years in Paris, he met the poets Max Jacob and André Salmon and the painters Chaim Soutine, Amedeo Modigliani, and Pablo Picasso, leading figures of the Parisian avant-garde. In 1912, Kisling exhibited at the Salon d'Automne and signed a contract with the art dealer Adolphe Basler. In 1914, he exhibited at the Salon des Indépendants. That same year, he volunteered for service in the French foreign legion. Wounded in the battle of Somme in 1915, Kisling was dismissed from active duty, naturalized, and traveled to Spain during his convalescence. Kisling returned to Montparnasse in 1916, and when the war ended, his studio became one of the main meeting places for the Circle of Montparnasse. He met and married the painter Renée Gros, the daughter of a high-ranking French military officer, the

next year. Kisling was praised during his first one-man show at the Galerie Druet in 1919, and became one of the most eminent painters of the School of Paris. Kisling's sons, Jean and Guy, were born in 1922 and in 1924. In 1925, Kisling participated in the Salon des Tuileries, as well as the Salon d'Automne and the Salon des Indépendants. He was named Chevalier de la Légion d'Honneur in 1933 in recognition of his prominence in the Parisian art world. In 1938, Kisling commissioned a home to be built for his family in Sanary on the Riviera. At the beginning of World War II, he volunteered for service in the French army, but after the Germans took Paris in June 1940 he fled, first to Marseilles, then to Portugal, and finally to America, arriving in New York in 1941. He lived on Gramercy Park and participated in an exhibition at the Whitney Museum of American Art. In 1942, he traveled to California to work for the pianist Artur Rubinstein and exhibited his work at the James Vigeveno Galleries. Kisling returned to New York in 1943 and established a studio on Central Park West, which became a meeting place for artists and intellectuals exiled from Paris by the war. Back in Paris by 1946, he received the Order of Merit of Public Health for his participation, while in America, in the Four Arts Association, an organization that collected clothing and food for artists and their families in France. He divided his time between Paris and Sanary until his death in 1953.

Jacques Lipchitz (1891–1973)

Born Chaim Jacob Lipchitz in Druskieniki, Lithuania, in 1891, he was the son of a successful building contractor who discouraged his interest in the arts. He began his studies in Belostok, Russia (now Bialystok, Poland), and continued in Vilna, where his father had intended him to pursue engineering. Nonetheless, with the encouragement and financial support of his mother and the advice of an uncle, Lipchitz went to Paris in 1909. In 1909-10, he studied at the École des Beaux-Arts, at the Académie Julian for sculpture classes, and at the Académie Colarossi for drawing classes. Lipchitz was then ordered to return to Russia to enlist in the military; however, he was released from service for medical reasons. He moved to Montparnasse around 1912, and through his friend the Mexican artist Diego Rivera formed friendships with the poet Max Jacob and the painters Amedeo Modigliani, Chaim Soutine, and Pablo Picasso. He collected tribal sculptures and art from other cultures. Lipchitz traveled to Spain in 1914 and studied the works of

El Greco, Jacopo Tintoretto, and Francisco de Goya, returning to Paris in 1915. In 1916, he met and married the poet Berthe Kitrosser and signed a contract with the art dealer Léonce Rosenberg. He fled Paris with his wife in 1918 because of the threat of German bombing, but returned within the year. During this time, he became friends with the Cubist artist Juan Gris and the writer Jean Cocteau. In 1920, he had his first one-man show at Rosenberg's Galerie de l'Effort Moderne, yet shortly thereafter broke from Rosenberg to pursue a more independent style. Lipchitz became a French citizen in 1924. He moved to the Parisian suburb of Boulogne-sur-Seine in 1925, where he commissioned Le Corbusier to build him a house. His first significant American exhibition was held at the Brummer Gallery in New York in 1935. In 1937, he was awarded the Gold Medal for his monumental sculpture, *Prometheus Strangling the Vulture,* at the Paris World's Fair. Germany invaded Paris in 1940, and Lipchitz and his wife fled to Toulouse. The couple then immigrated to New York in 1941. After a visit to Paris to be named Chevalier de la Légion d'Honneur, Lipchitz returned to the United States in 1947. The Museum of Modern Art held a retrospective of his work in 1954 that traveled throughout the United States. He received an honorary doctorate from Brandeis University in 1958, and that same year became a United States citizen. Lipchitz lived in America from 1941 until his death, with frequent trips to Paris, Israel, and Italy. He died on the island of Capri in 1973 and is buried in Jerusalem.

Mané-Katz (1894–1962)

Mané-Katz, né Emmanuel Katz, was the son of a synagogue beadle in the Ukraine. Although he was steeped in talmudic study, he was nevertheless encouraged by his father in his desire to become an artist. He studied at the School of Fine Arts in Kiev and in 1913 arrived in Paris, sponsored by a relative who provided a letter of introduction to a wealthy collector. He enrolled in Fernand Cormon's class at the École des Beaux-Arts, where he met his compatriots, Chaim Soutine and Marc Chagall. On visits to the Louvre, he admired the paintings of Rembrandt, which influenced him greatly, while private galleries opened the new worlds of the Fauves, the Cubists, and the Surrealists. However, the artist was also inspired by his Jewish heritage, painting quintessential scenes of Jewish life in an Expressionistic style. Mané-Katz returned to Russia in 1914, remaining there for seven years. Back in Paris, he received his first one-man show in 1923 at the Galerie Percier, organized by Waldemar George. In 1927, Mané-Katz became a French citizen. The following year, he made the first of many trips to Palestine, establishing a second home in Haifa. At the Paris World's Fair in 1937, his painting, *The Wailing Wall,* won the Gold Medal. During World War II, Mané-Katz fled to the United States but subsequently returned to France. The Tel Aviv Museum gave him a one-man show in 1948, amid Israel's War of Independence. In 1951, he was named Chevalier de la Légion d'Honneur. The artist died in Israel in 1962. His home in Haifa later became the Mané-Katz Museum.

Louis Marcoussis (1878–1941)

Marcoussis was born Louis Casimir Ladislas Markus in Warsaw in 1878 to a rich Jewish industrialist. His family converted to Catholicism early in his life. During his early twenties, Marcoussis studied law in Warsaw and painting at the Academy of Fine Arts in Kraków before leaving for Paris in 1903. He refused to study decorative arts, which would have benefited the family's carpet manufacturing business, so his father no longer provided him with an allowance – until his son proved himself with honors in drawing. He enrolled for a short period at the Académie Julian, but spent most of his time at the Louvre, salon exhibitions, galleries, and cafés. Financial support from home ended in 1905. Marcoussis then obtained work as an illustrator for the magazines *La Vie Parisienne* and *L'Assiette au Beurre.* He continued to paint, and by 1907 had become influenced by Fauvism. At the Cirque Médrano in 1910, he met the poet Guillaume Apollinaire and the artist Georges Braque, who introduced him to Pablo Picasso. That year, he lost his live-in girlfriend, Marcelle Humbert, to Picasso and, at the suggestion of Apollinaire, adopted the surname Marcoussis, after a small village in the Essonne district. In 1912, he showed with other Cubists at the *Section d'Or* exhibition. He had developed a Cubist style that favored still life and subjects that made reference to music, much like the work of his friends Picasso and Braque in Montmartre. Marcoussis left illustration in 1913. That same year, he married the painter Alice Halicka, a compatriot, and moved to the Rue Caulaincourt, where they lived until 1939. Because of his service in the French army during World War I, he was awarded citizenship. Around 1926, he rediscovered printmaking and was extremely productive in this medium throughout the 1930s. To supplement his income, he taught engraving at Schapfer's studio in Montparnasse in 1933 and

became a personal decorator and art-collecting adviser to the cosmetics manufacturer and philanthropist, Helena Rubinstein. Marcoussis spent a year in New York in 1934, and his engravings were exhibited in New York and Chicago. A month before the German occupation of Paris in 1940, Marcoussis and his wife left for safety in Vichy, where he died of lung cancer in the autumn of 1941.

Amedeo Modigliani (1884–1920)

The son of a tradesman, Amedeo Clemente Modigliani was born in Livorno in 1884. Both his parents came from the prominent Sephardic Jewish community. Throughout his childhood, his health was delicate, and Modigliani was eventually diagnosed with tuberculosis. From an early age, he showed great interest in painting and drawing. Although his mother was reluctant to have her son pursue a life in the arts, Modigliani entered the art academy of Guglielmo Micheli in Livorno in 1889. He trained in the tradition of Impressionism, concentrating on landscapes, portraits, still lifes, and nudes. He traveled through southern and central Italy in 1901. In 1902, he decided to become a sculptor after visiting the stone quarries of Pietrasanta and Carrara. From 1903 to 1906, Modigliani was a student at the Reale Istituto de Belle Arti in Venice, where he met Umberto Boccioni. In the Venice Biennale of 1903 and 1905, Modigliani discovered Symbolism and French Impressionism, the sculpture of Auguste Rodin, and the paintings of the English artist James A. M. Whistler. He was especially impressed by the work of Henri de Toulouse-Lautrec, which inspired him to leave Venice for Paris, the center of the avant-garde art world. He arrived in Paris in 1906, found an apartment in Montmartre, and enrolled at the Académie Colarossi. He quickly associated himself with the artists Pablo Picasso, Diego Rivera, and André Derain and with the poet Guillaume Apollinaire. Modigliani formed close friendships with the Jewish artistic and intellectual community in Paris at that time, which included Max Jacob, Chaim Soutine, Moïse Kisling, and Jacques Lipchitz. In 1907, he became a member of the Société des Artistes Indépendants and exhibited at the Salon d'Automne. The year before, the Salon had held a retrospective of works by Paul Cézanne, aspects of which greatly impressed Modigliani and surfaced in his own paintings, along with the influences of Toulouse-Lautrec and Paul Gauguin. In 1908 and 1910, he again exhibited at the Salon des Indépendants. By 1909, he had moved to Montparnasse, where he began

working with the sculptor Constantin Brancusi. He lived with the English poet Beatrice Hastings in 1914 and 1915, during which time he sold his first works through the art dealer Paul Guillaume. Léopold Zborowski soon replaced Guillaume as his dealer and formed a bond with Modigliani that would last the artist's lifetime. In 1917, Modigliani met Jeanne Hébuterne, with whom he lived the last few years of his life. The two traveled to the south of France in 1919, and returned to Paris that year with a daughter. Modigliani's health continued to fail and, in 1920, he died of tubercular meningitis in the Hôpital de la Charité in Paris. The next day, Hébuterne, several months pregnant, committed suicide.

Elie Nadelman (1882–1946)

Born in Warsaw, Elie Nadelman was the seventh child of Hannah Arnstan and Philip Nadelman, a jeweler. As a teenager, he studied at the Warsaw Academy of Fine Arts. In 1904, he visited Munich, where he was influenced by the classical Greek sculpture and the collection of dolls and folk art in the local museums. After six months in Munich, he went to Paris, where he lived for ten years. There, he enrolled at the Académie Colarossi and rented a studio in Montparnasse. Nadelman was given his first one-man show of drawings and sculptures at the Galerie Druet in 1909. He had his second one-man show, which included fifteen marble heads, in 1911 at Paterson's Gallery in London. This entire exhibition was bought by Helena Rubinstein, who became his patron. In 1913, Nadelman participated in the seminal Armory Show in New York. The next year, with Rubinstein's help, he immigrated to the United States, settling permanently in New York. There, Alfred Stieglitz mounted the artist's first one-man show at 291. From 1917 to 1924, Nadelman created drawings and sculptures of musicians, acrobats, and equestriennes that were inspired by his love of folk art and the world of performers. At his home in Riverdale, New York, he amassed a huge collection of folk art. In his later years, Nadelman worked mostly in plaster, producing figurines based on Greek prototypes as well as contemporary entertainers. He died of heart disease in Riverdale in 1946. In 1948, The Museum of Modern Art mounted a memorial retrospective, *The Sculpture of Elie Nadelman*. The Whitney Museum of American Art presented its retrospective, *The Sculpture and Drawings of Elie Nadelman, 1882-1946*, in 1975.

Selected Bibliography

Aimot, J.-M. *Mané-Katz*. Paris: Éditions Marcel Seheur, 1933.

Aries, R. S. *Mané-Katz, 1894-1962: The Complete Works*. London: Éditions d'art Jacques O'Hana, 1970.

Baal-Teshuva, Jacob, ed. *Chagall: A Retrospective*. Southport, Connecticut: Hugh Lauter Levin Associates, 1995.

Baron, Stanley, in collaboration with Jacques Damase. *Sonia Delaunay: TheLife of an Artist*. New York: Harry N. Abrams, Inc., 1995.

Baur, John I. H. *The Sculpture and Drawings of Elie Nadelman*. Exhibition catalogue. New York: Whitney Museum of American Art, 1975.

Bernier, Georges, and Monique Schneider-Maunoury. *Robert et Sonia Delaunay: Naissance de l'art abstrait*. Paris: J.-C. Lattès, 1995.

Bougault, Valérie. *The Heyday of Modern Art, 1910-1940: Paris, Montparnasse*. Paris: Terrail, 1997.

Buck, Robert T., Sherry A. Buckberrough, and Susan Krane. *Sonia Delaunay; A Retrospective*. Exhibition catalogue. Buffalo: Albright-Knox Art Gallery, 1980.

Caracalla, Jean-Paul. *Montparnasse: L'Âge d'or*. Paris: Denoël, 1997.

Cassou, Jean. *Louis Marcoussis*. Paris: Librarie Gallimard, 1930.

Castaing, Marcellin, and Jean Leymarie. *Soutine*. Paris: Bibliothèque des Arts, 1963. Translated as *Soutine*. New York: Harry N. Abrams, Inc., 1963.

Ceroni, Ambrogi. *Amedeo Modigliani: dessins et sculptures*. Milan: Edizioni del Milione, 1965.

———. *I dipinti di Modigliani*. Milan: Rizzoli, 1970.

Chagall, Marc. *Ma Vie*. Paris: Stock, 1970.

Chaim Soutine: Centenary Exhibition. Exhibition catalogue. Tokyo: Odakyu Museum, 1992.

Chiappini, Rudy, ed. *Chaim Soutine*. Exhibition catalogue. Lugano, Italy: Museo d'Arte Moderna, 1995.

———. *Amedeo Modigliani*. Exhibition catalogue. Lugano, Italy: Museo d'Arte Moderna, 1999.

Cogniat, Raymond. *Soutine*. Paris: Flammarion, 1973. Translated as *Soutine*. New York: Crown, 1973.

Cohen, Arthur A. *Sonia Delaunay*. New York: Harry N. Abrams, Inc., 1975.

De Voort, Claude, and Jean Kisling. *Moïse Kisling, 1891-1953*. Paris: ADAGP, 1996.

Douglas, Charles. *Artists' Quarter: Reminiscences of Montmartre and Montparnasse*. London: Faber and Faber, 1941.

Drot, Jean-Marie, in collaboration with Dominique Polad-Hardouin. *Les heures chaudes de Montparnasse*. Exhibition catalogue. Paris: Hazan, 1995.

Dutourd, Jean. *Kisling, 1891-1953*. Edited by Jean Kisling. Vol. III. Paris, 1995.

Forge, Andrew. *Soutine*. London: Spring Books, 1965.

Gautherie-Kampka, Annette. *Les Allemands du Dôme:La Colonie allemande de Montparnasse dans les années 1903-1914*. Bern and New York: P. Lang, 1995.

Gauthier, Maximilien. *Mané-Katz*. Paris: Les Gémeaux, 1951.

George, Waldemar. *Artistes juifs: Soutine*. Paris: Éditions le Triangle, 1928.

———. "The School of Paris." In Cecil Roth, *Jewish Art: An Illustrated History*. Revised edition by Bezalel Narkiss. Greenwich, Connecticut: New York Graphic Society, Ltd., 1971.

Golan, Romy. *Modernity & Nostalgia: Art and Politics in France Between the Wars*. New Haven and London: Yale University Press, 1995.

Goodrich, Lloyd. *Max Weber*. Exhibition catalogue. New York: The Whitney Museum of American Art, Macmillan Company, 1949.

Hammacher, A. M. *Jacques Lipchitz: His Sculpture*. New York: Harry N. Abrams, Inc.,1960 and 1965.

Hemin, Yves. *Pascin, Catalogue raisonné: Peintures, aquarelles, pastels, dessins*. Paris: Editions Rambert, 1984.

Hope, Henry R. *The Sculpture of Jacques Lipchitz*. Exhibition catalogue. New York: The Museum of Modern Art, 1954.

Keobandith, Pick. *Elie Nadelman: Les Années parisiennes, 1904-1914*. Exhibition catalogue. Paris: Galerie Piltzer, 1998.

Kessel, Joseph. *Moïse Kisling*. Edited by Jean Kisling. New York: Harry N. Abrams, Inc., 1971.

Kiki. *Kiki's Memoirs*. Introduction by Ernest Hemingway and Foujita. Hopewell, New Jersey: Ecco, 1996.

Kirstein, Lincoln. *The Sculpture of Elie Nadelman*. Exhibition catalogue. New York: The Museum of Modern Art, 1948.

——. *Elie Nadelman.* New York: The Eakins Press, 1973.

Kisling, Jean, ed. *Kisling, 1891-1953.* Vol. II. Paris, 1982.

Kleeblatt, Norman L., and Kenneth E. Silver. *An Expressionist in Paris: The Paintings of Chaim Soutine.* Exhibition catalogue. Munich and New York: Prestel-Verlag and The Jewish Museum, 1998.

Klüver, Billy, and Julie Martin. *Kiki's Paris: Artists and Lovers, 1900-1930.* New York: Harry N. Abrams, 1989.

Kofler, Hana, ed. *Chana Orloff: Line & Substance, 1912-1968.* Tefen Industrial Park, Israel: The Open Museum, 1993.

Kuthy, Sandor, and Meret Meyer. *Marc Chagall, 1907-1917.* Exhibition catalogue. Berne: Museum of Fine Arts Berne, 1995.

Lafranchis, Jean. *Louis Marcoussis.* Paris: Éditions du Temps, 1961.

Leymarie, Jean. *Soutine.* Exhibition catalogue. Paris: Orangerie des Tuileries, 1973.

Lipchitz, Jacques. *Amedeo Modigliani.* New York: Harry N. Abrams, Inc., 1954.

——. *My Life in Sculpture.* New York: The Viking Press, 1972.

Madsen, Axel. *Sonia Delaunay: Artist of the Lost Generation.* New York: McGraw-Hill, 1989.

Mancilhac, Felix. *Chana Orloff.* Paris: Les Éditions de l'Amateur, 1991.

Mané-Katz et son temps. Exhibition catalogue. Geneva: Petit Palais, 1969.

Marc Chagall: Les Années russes, 1907-1922. Exhibition catalogue. Paris: Les Musées de la Ville de Paris, 1995.

Meyer, Franz. *Marc Chagall: Life and Work.* New York: Harry N. Abrams, Inc., 1964.

Milet, Solange. *Louis Marcoussis: Catalogue raisonné de l'oeuvre gravé.* Copenhagen: Forlaget Cordellia, 1991.

Modigliani, Jeanne. *Modigliani, Man and Myth.* New York: The Orion Press, 1958.

Morano, Elizabeth. *Sonia Delaunay, her Art and Fashion.* Introduction by Diana Vreeland. New York: George Braziller, Inc., 1985.

North, Percy B. *Max Weber: American Modern.* Exhibition catalogue. New York: The Jewish Museum, 1982.

Parisot, Christian. *Modigliani, Catalogue raisonné.* 2 vols. Rome: Editions Graphis Arte, 1991.

Raynal, Maurice. *Modern French Painters.* New York: Brentano's Inc., 1928.

Retrospective Kisling. Exhibition catalogue. Paris: Société du Salon, 1984.

Retrospective Sonia Delaunay. Exhibition catalogue. Paris: Ministère d'Etat Affaires Culturelles, 1967.

Schmalenbach, Werner. *Amedeo Modigliani: Paintings, Sculptures, Drawings.* Munich: Prestel-Verlag, 1990.

Schneider, Pierre. *Chagall à travers le siècle.* Paris: Flammarion, 1995.

Schuster, Bernard. *Modigliani, A Study of His Sculpture.* Jacksonville, Florida: NAMEGA, 1986.

Schwarz, Karl. *Jewish Artists of the 19th and 20th Centuries.* Freeport, New York: Books for Libraries Press, for Philosophical Library, Inc., 1949, reprint 1970.

Silver, Kenneth E. *Esprit de Corps: The Art of the Parisian Avant-Garde and the First World War, 1914-1925.* Princeton: Princeton University Press, 1989.

Silver, Kenneth E., and Romy Golan. *The Circle of Montparnasse: Jewish Artists in Paris, 1905-1945.* Exhibition catalogue. New York: Universe Books, 1985.

Soby, James Thrall. *Modigliani: Paintings, Drawings, Sculpture.* Exhibition catalogue. New York: The Museum of Modern Art, 1951.

Troyant, Henry. *Moïse Kisling.* 2 vols. Paris: J. Kisling, Ages arti grafiche, 1982.

Tuchman, Maurice. *Chaim Soutine, 1893-1943.* Exhibition catalogue. Los Angeles: Los Angeles County Museum of Art, 1968.

Tuchman, Maurice, Esti Dunow, and Klaus Perls. *Chaim Soutine (1893-1943): Catalogue Raisonné.* 2 Vols. Cologne: Benedikt, 1993.

Warnod, Jeanine. *La Ruche et Montparnasse.* Paris-Genève: Weber, 1978.

Werner, Alfred. *Max Weber.* New York: Harry N. Abrams, Inc., 1975.

Wheeler, Monroe. *Soutine.* Exhibition catalogue. New York: The Museum of Modern Art, 1950.

Wilkinson, Alan G. *Jacques Lipchitz: A Life in Sculpture.* Exhibition catalogue. Toronto: Art Gallery of Ontario, 1989.

——. *The Sculpture of Jacques Lipchitz: A Catalogue Raisonné.* Introduction by A. M. Hammacher. London and New York: Thames and Hudson, 1996.

64